D1544956

THE SILENT P IS FOR POSTER

The Silent P is for Poster

FOREWORD BY JEFF TWEEDY
with an
INTRODUCTION BY DAVID CARSON

Credits

Photography

All photography copyrights stay with the photographers.
Zorin Orlic: Wilco, Nels Cline Singers, The National, Everest, Jeff Tweedy
Marc Lowenstein: Tedeschi Trucks Band
Adam Levy, Ashley Rick: The Honeydogs
Anthony D'Angio: Eric Church
Darin Back: Schizophonics, "Tools of the trade" shot (this page)
Kathrin Baumbach: Empire Circus
Chester Desmond: A Winged Victory for the Sullen

Foreword
by
Jeff Tweedy

A few years ago at Solid Sound, the festival Wilco curates every other year on the incredible MASS MoCA campus in the Berkshires, we presented an installation of our concert posters. There were hundreds of them. Arranged chronologically. Walking from the earliest shows towards the most recent filled me with a strange and powerful set of emotions I had failed to anticipate. I cried! Ok, yes, I cry a lot. But I was truly moved by the experience.

Why? When I had originally been presented with the idea of displaying, in one place, the sizable collection of the art we'd sold at our shows and/or used to promote our gigs over the years, I was skeptical. I had it in my mind that the varying art styles, printing methods, and sizes would create a fairly incoherent albeit colorful mess. Especially within the carefully curated context of a world-renowned art facility. Still, the idea had its charm, and ultimately, proved to be irresistible. So what if dozens of different artists hung together on the same wall felt cacophonous? At least it'd be fun to see so much of it in one place. Right?

So. What was it? What brought tears to my eyes in the brightly lit gallery hall? Time?

At first I thought it was the weight of time, and the feeling of endurance, that tipped the scales towards melancholy. All of the dates rushing forward. October 8th, July 27th, February 3rd… even without the year (it's rarely necessary to inform concert-goers of the year they are currently in), it really did feel like as much of a visual montage of my life in music as one could imagine. As a whole, the display really nailed the vibe of one of those Roman Empire timelines in a history book.

Were the names of all the now familiar-to-me clubs and performing spaces creating some kind of memory map of my travels? I was surprised at how many individual posters brought back vivid images of dressing rooms and theater chairs. Along with weird gut recollections of the performances themselves. "Ooooh…Philly Theater of the Living Arts, that was a scorcher," or "Yikes, Maxwells! That was a rough night."

But as satisfying as those explanations are to contemplate, I still don't think either one accounts for the intensity of my feelings that day.

Here's what I think hit me.

The reality of the community and connection, which I believe is elemental to the whole notion of making music and art for each other, was made fully visible to me that day.

I mean, I knew that reality was real. But here it was to look at! All of these different illustrators and artists hanging side by side, united by something not a single one of us gets to see in its enormous entirety. All of the people running these bars and theaters, connected by paper and ink. The kids at the clubs, and the older folks in the theaters, all a part of an ageless hidden hand shaping one corner of the world, a corner that's not as small as you might think. All the power being generated by all of the hearts. And knowing this particular exhibit was but a fraction of the joyful congregation around just one band. My band. What a world!

So what we have in this book is another visitation, this time linking more bands, more communities, more joy. More glimpses of something that shouldn't feel so uniquely connected, but, undeniably, is in fact whole. There's passion here that belies the commissioned status of these works of art. What coheres in these images is the work of many communities intertwined and invested in each other.

Books like this are as close as one can get to the solid evidence that we all crave--the proof that what happens when we create is beyond the scope of the individual work. One cannot create without creating other creators. That is something I've said before, and it is something I deeply believe. I need to believe it, because it gives me hope.

What made me cry that day at the museum, and touches me here looking at this collection, is the relief one gets when overwhelming evidence supporting what they secretly believe is laid out in front of them. I'm not crazy after all! You're not crazy! The world we feel around us in the dark--the one we have faith in—exists. It's here! Behold the work of our shared belief in each other. And let it make you make something, too.

OxO
Jeff Tweedy
Chicago, Illinois
January, 2022

Introduction
by
David Carson

 pposters (first p is silent)

i made an unfortunate move to charleston south carolina some years ago. one fond memory after i opened my studio was a visit by a designer who's work i had been noticing and liking, silent p. what a great name i always thought, and what a pleasant experience it was to meet him and his partner when they came by the studio (in americas "most polite" city. not friendliest, most polite) they were and as far as i know continue to be really normal nice folks. and now I'm honored to write a small bit for his poster book, and also honored to be on the bill with wilco.

when i was designing ray gun magazine, i really enjoyed the couple of trips i made to seattle, mainly because of the rich poster culture in the streets. it was early 90's and seattle had so many great bands and posters all over the city. i took alot of photos, and posters...+bits of posters of course, the torn bits were often great. portland came close in terms of street wandering for great posters and leftovers, but seattle was the best......some years later i returned and went out to steal and fotograph posters, but it was the first time i found nothing. i couldn't put my finger, or hands, on it at the time, but all the posters were small, clean and neat with these little white borders, sanitized and boring. i learned later the progress of street poster , especially for concerts , but really for any kind of announcement was: one stop shopping! We'll design , print, put up and take down , on time, your posters! it basically killed the golden age and allure of posting and posters in seattle. and many other cities .except in latin america amsterdam. and barcelona. so, like all of us, silent pee is a dying breed. now the companies that put up, take down your poster and cant print bleeds, have taken over. and were all much poorer for it.

matt's design,like all good design, first draws u in, gets your attention, then lets you discover more. its smart, unexpected and always seem to represent the band in unexpected and near perfect ways, not the obvious ways...i like to think, and do, that no two pages of the 30 issues i did of ray gun magazine, look the same, yet somehow manage to feel connected. the same happens with matt's work. original, fresh, +not something teachable in design school. he pulls from within, where all the

best work comes from. the wilco stuff is classic, they both were fortunate to have each other in those collabs.....kudos to wilco and the other bands for letting it happen, and for matt for using his unique vision, design sense and sense of humor, to make these posters sing, much like the music itself does.

the best graphic designers are also authors. with print u get real, tactile, smell, unique...no software involved.....i woulda loved to murk/lurk around matt's trash bin during the day for some hidden test sheet gems i could later add collage too, sending stuff back thru backwards, using old test sheets for new work, all of it. especially love the blue oven wilco one. (uncle tupelo played often during the making of early ray guns)....the human touch and eye drips thru in all matt's work.

savor this book. savor each piece shown. think how you might have done it. thats ok too. and notice the smell, weight and texture of what you're holding. be aware of it. whenever i got a new issue of ray gun back and saw for the first time, i had to put it through these tests: weight-did it feel substantial or that we were going out of business? ..2. the smell. 3 the texture of the cover and inside pages. only then was the design checked, where some of it worked and some of it didn't.
you wont find any of matt's work here that didn't.

enjoy this collection, can't wait to see the next edition and where matt takes his amazing work next chapter.

every graphic designer should read and study this book. every non graphic designer should too.

davidcarson, nyc, nov.16, 2022.
in the window of some coffee/book store that has "no technology allowed" signs on the best seat+tables...weird. upper west side.

Like many other books that have been created before it, the book in your hands has taken much longer than expected to produce, and has taken many, many hours to compile and develop into something I was really happy to present to fans of poster art and design, as well as music fans.

The years represented here felt like a well rounded collection of this creative body of work. The Covid 19 pandemic pushed the 'pause' button with all music clients touring in 2020, thus giving me some additional time to finally sit down at my standing desk and get this collection compiled.

–Cheers,

Year by Year S T O R I E S & Production Notes

2007

A pivotal year - it is the year I got to create my first official screen printed poster for a client (page 16); that client being the first band to give me a chance - WILCO. I'm forever indebted to Wilco and the then band manager, Ben Levin and the current manager, Crystal Myers. As this book will show, since 2007 that first job from Wilco led to just a few others in the years since.

On page 20 there's a reproduction of an old tin type I picked up at a flea market - an unidentified man sitting with a bowler hat in his lap. If anyone knows who this is, please let him know, the sharp dressing chap doesn't know he's famous.

2007 was also the year I got the chance to create a poster for one of my favorite song writers ever, Neil Finn of Crowded House. Amazing. I got to meet Neil at Wilco's *Solid Sound Festival* in 2011 as he walked around backstage - I tried not to come across like a giddy school girl, but what's a fan to do? And finally...Mitch Easter? Enough said.

2008

Some humorous tidbits from this year. The Wilco poster for Baltimore (page 28) is the only time I included an image of myself in a design. I'm around 10 years old, cute as ever. Also, on the same poster is an image of my hand x-ray taken from when I thought I broke my finger playing flag football. Blood, sweat and tears go into this stuff folks.

Page 29 features yet another tin type purchased from a flea market (a phase I guess) - I hand drew all the facial hair to spell 'Wilco', scanned it and composed it all on a Mac. The Charleston, South Carolina show featured on page 27 actu-

ally was a complete re-do. The original date was several months earlier, but when Wilco was invited to play *Saturday Night Live*, understandably they took the gig. The poster art had already been approved and also printed. So, I ended up with a box of unusable Wilco posters, but not to worry, I put the poster stock to good use, by way of free sketch pad front and back covers.

The Black Keys poster for Toledo, Ohio on page 31 (I spent a good chunk of my childhood there, 'Go Mudhens!') was probably the most ridiculous turn around to date. The deadline took two days: Art one day, printed the following, then shipped. Pretty insane! Band of Horses poster (page 31) features something from the old days of graphic art when many tasks were done by hand: 'Rubylith' - which is a brand of masking film. I just liked how it looked on the sheet, with all the random parts and chunks cut and trimmed out of it from various past projects, so I scanned it and manipulated the color on the Mac. Rubylith was used in many areas of graphic design, typically to produce masks for various printing techniques. "Old school", for sure.

2009

This section features a not-so-subtle nod to Terry Gilliam's animation style from the ground breaking *'Monty Python's Flying Circus'* for Wilco's London show (page 39). The lovely chap featured is originally from an ad campaign my dad's ad agency ran in the early 80s for a regional fish and chips fast food chain up and down the East coast.

'The Dude' poster on page 43 is a special one, since I got to collaborate with my older brother Mark on it. It was originally produced for Leia Bell's Signed and Numbered show "This Aggression Will Not Stand, Man". Continuing the family connections, the headphones featured on page 37 are my dad's

old headphones that I still have. It's dawning on me that 2009 was the family connection year - on page 42 I used (with permission) one of my mom's wedding photos for the *Mother Mother* poster. Subtle, again.

For the entire poster series used to promote Wilco's film *"Ashes of American Flags"* (pages 46-47), I loved getting to feature my good friend Zoran Orlic's beautiful images. Zoran's work is a thing of beauty!

2010

The poster for Modest Mouse (page 50) is a favorite of mine, partly because it includes the following short story. I met Isaac Brock in Portland, Oregon at an art show I was in (I promise it was not a *Portlandia* episode). We chatted outside the gallery for a bit, mostly about art and music. I returned home to North Carolina and by staying in touch through emails, I find out Modest Mouse is coming to my backyard: *The Orange Peel* in Asheville, NC (voted one of the Top 10 venues in America). Isaac agrees to see some potential art for the show, so I get to work. I present around ten ideas (in hindsight NEVER present 10 ideas to any client) and he likes two as potential for the date. As per normal in the music poster business, we're now rushed to meet the deadline. Isaac eventually emails his final choice out of the two, which is what you see in this book. After rushing every aspect of this poster, I now have posters in hand and deliver them to the then tour manager backstage - the tour manager asks me how much did Isaac agree to pay me - I tell him, to which he says, "I woulda NEVER agreed to that much." - nice. Modest Mouse is now doing the LOUDEST sound check I've ever witnessed to this day, I loved it. Afterwards, Isaac meets me and asks, "I saw the poster, looks great...where's the second one we agreed to do?" I guess he thought his telling me he "liked both posters" (the two from the initial set sent) that I'd actually gone ahead and run those two, etc. Awkward for both of us, probably more so me. He was kind enough to not make a big deal about it and my friend and I did get to hang a bit in the not-so modest tour bus. All in all, a great (and awkward) night.

There's the hilarious story about the now infamous Phish poster from Hershey, Pennsylvania (page 58). The client approved the sketch that was sent with photo references which included images of the old Hershey's chocolate can from the 1970's, clearly showing the kid character on the front. Fast forward to once again being under a tight deadline (are you seeing a pattern?) I'm preparing final color separations and literally getting ready to send everything to the printer. I get an urgent message from the client saying "Hershey stadium says they cannot hang the poster with the old can!" Why, I ask? "It's copyrighted". The client now has to jump through hoops to come up with what is to me still an unknown arrangement with the Hershey people in order for Phish to sell the thing at their own show.

And after all that, most Phish fans *hated* it. Which when I picture a Phish fan typing a hate message to me (Yeah, I received several) THAT makes me smile and laugh about this most ridiculous poster situation *ever*. Whatever happened to peace, love and understanding?

2011

Admats. One word: 'Yuck'. Heck, probably three words: 'Very much yuck'. *Always* crazy tight deadlines and dealing with very unreasonable rates - just say 'No', kids. It does however, give opportunities to do work with big names like some lady named 'Gaga' (page 70).

I've always loved synth based music (*Devo, Depeche Mode, New Order, Thomas Dolby*) so to get the chance to create a poster as part of a Moogfest art show was special (page 69). Our beautiful home of Asheville, North Carolina used to be the host city.

I skateboarded in the 80s, both my big brother and I loved it. My old *Vision Gator* board is still with me and I still get out for the occasional skate session. I love skate art & culture, so it was cool when worlds collided on the poster created for Trey Anastasio's Oakland, California poster (page 74). The research involved was so fun, the joy of searching all the old school skate decks and old skate company logos I loved back in the day.

I was commissioned by Wilco to create a complete poster series for *"Wilco's Incredible Shrinking Tour of Chicago" (pages 76-81)*. Five dates, five different venues in Chicago, and thus five gig posters. We ended up flocking every one of the posters - 'flocking' is the process of depositing many small fiber particles onto a surface. It adds a third dimension, creating that unique raised, red-velvet texture. Was thrilled to hear they sold out every single night of each show. I have one complete set here in the studio, a special keepsake for sure.

This was also the year we got to help develop all the *Solid Sound Festival* related print & web items, the entire weekend program, posters etc. A special moment was getting to meet Jeff for the first time backstage. Unbeknown to me, he was waiting for his cue to go onstage to join another band's cover version of "I am Trying To Break Your Heart", much to the audience's joy. It was a hilarious segue from Jeff saying "Nice to meet you" to *immediately* darting out the door to go sing his heart out. Good times.

2012

The band Everest had reached out to see if I might help them with several projects, one of which was the album art for their upcoming release 'Ownerless'. (page 87) They make their national TV debut on the *Late Show* with David Letterman (a personal hero of mine). To introduce the band, David Letterman holds up the album art I created for the band, just a very cool moment. As the song ended, Letterman walks over to shake the guys' hands, album in hand, he says "I would like to manage the band, if that's alright...no more of this van crap, business class, you hear what I'm saying? Business class!".

Such a great, classic moment, and maybe if Letterman *was* their manager, they would've been better off. Please go look up *Everest*, they were discovered by Neil Young, which is a nice segue to this nugget: I saw Everest and Crazy Horse play in DC with Patti Smith, a great line up. As we hung out in their green room, I was leaning on the door frame, halfway into the hallway when Neil and Crazy Horse popped into the hallway from their room which was directly across (this is mere moments before they make it to the stage) - I give Neil a head nod as we looked at each other...I will always cherish the head nod I got back from Mr. Young...just an amazing night all around.

2012 was also the first year we started working with Eric Church and his management. It's been fun to help a once struggling local musician (Eric spent some time in and around Hickory, NC where we at one time lived and had studio space) to see his career completely blow up after his time in Nashville.

2013

We started a great working and personal relationship with Empire Circus this year (formerly STAND) from Dublin, Ireland. Another band in the long list of "Bands That Should Be Huge" category...seeing them live was the thing (or 'ting' if yer Irish) - no matter how many people showed up for the shows, they always played like it was a packed *Madison Square Garden*. I got to see them several times, twice in Ireland, also in New York City at *The Mercury Lounge* and once in my hometown of Asheville, NC. The Asheville show was attended by my wife and I and their manager...and the bartender. Taking it in stride, after the show we all went to dinner together, and Alan (lead vocal, guitar) says wryly, "Well, it's not often you get to have dinner with the entire audience after a show!" Got to love the Irish sense of humor.

2014

It's a much more fulfilling experience any time an artist gets to work with his/her hands I think. So, for the Mike Gordon poster (page 118) I gave myself a personal challenge: "Make the poster art as much by hand as possible". The digital parts only came when I needed to scan the multiple torn pieces and shards of paper that create the top portion of the poster to set the typography up. To this day it's one poster I really did enjoy the creative process of a lot more than others. It was brought to life by Justin Dickau of Fairweather Press in Oregon. Mike Gordon and Phish's manager said "He absolutely loves it, one of his favorites this tour!". Music to my ears.

A Winged Victory for the Sullen (page 118) tested the detail limits of screen printing - Lars P. Krause, of Douze in Germany made these super intricate posters work - complete with metallic inks.

To get to work with Nels Cline and Julian Lage, two of the most innovative guitarists out there (and both super nice dudes as well!) was a thrill (page 123)

The Wilco poster for Raleigh Museum of Art is my not-so-subtle nod to Sol LeWitt (page 125).

2015

'Spam' is something you don't want in your email. It's not everyday you get an email *from Spam*...I mean to say, it's not everyday the company SPAM® emails you a non Spam (but VERY spammy) email. It was so much fun to work with Hormel's ad agency BBDO Minneapolis and Ink Floyd to represent Charlotte as part of the SPAMERICAN Tour. A 12-city cross-country Spamerican Tour that was led by brand ambassador (and Food Network chef) Sunny Anderson. Charlotte is home to NASCAR so that was a big draw visually among the several concepts I presented. You know what they say, "If you ain't first, you're last!" In the end I'm so thankful that the email didn't go to Spam...and with that I think we've reached our bad pun limit. (page 129)

I designed the poster and promo material for Wilco's excellent music documentary *"Every Other Summer"* directed by Christoph Green and Brendan Canty. *Every Other Summer* is a documentary about the Solid Sound Festival, Wilco's three day music and arts gathering that takes place once every two years at MASS MoCA. The film offers a peek into the festival's utopian vibe, and the positive transformative impact it has had on the small rust belt town of North Adams, Massachusetts.

This was also the year that Wilco released the first collection of posters in their beautiful book *"Beyond The Fleeting Moment: Wilco Concert Posters 2004-2014"*. Such a great collection of a wide variety of poster work by a lot of artists I highly respect.

2016

Alabama Shakes may have been my first foray into printing on foil poster stock (page 136). The washboard concept worked great set against the silver shine of the foil. But overall, I haven't done a lot of foil posters, mainly because sometimes it felt a tad cheesy to me. The foil styles can tend to overwhelm the actual art - but, there are studios out there that use it very creatively - and clearly poster fans love it, and if that's your bag, there's a few talented poster studios that do it well (looking at you Status Serigraph!).

I was in Asheville, NC visiting one of my favorite record stores (shout out to Harvest Records!) when I asked, "What band's record can you not get enough of lately?". That's when he showed me Band of Horses "Everything All The Time". At the time I did not realize all the Asheville connections (two of the then members called Asheville home) and a lot of recoding was done at Asheville's revered *Echo Mountain Recording Studio*.

2017

Working with Ben Harper's management on posters for his special acoustic tour led to a heartwarming moment for me. While on a phone call with Ben's wife who was helping approve the art during the creative process, Ben's opinion could be heard in the background, "Yeah, looks great!" Made my day. I've gotten to do several posters for Ben, every one of them fun.

The poster for Eric Church's show in Greensboro, North Carolina (page 149) includes a not-so-subtle nod to Eric's being a big fan of the North Carolina Tar Heels - the ram mascot. Eric's fans are some of the best poster fans to date - I am happy to be published in Eric's concert tour book, *"61 Days In Church"*, all the poster art from his 'Holdin' My Own' tour.

2018

We did a fun giveaway for Jeff Tweedy's Royal Oak, Michigan poster (page 160). Every poster sold came with a classic tree car air freshener. Art has never smelled so fresh!

Page 156 features another fun one for Jeff. I actually came up with the idea during Jeff's show in Saxapahaw, NC at the *Haw River Ballroom*. We drove to see the show and to deliver the posters for that night. As I visited with Wilco and Jeff's long time logistics, road crew and merchandise manager Andy, Jeff started to play "Let's Go Rain" which has the lyric :

"Oh I should
Build a wooden ark
Wouldn't you rather live
On an ocean of guitars?"

With great lyrics like that, the concept made itself.

2019

This year was the year for triptychs. Our first ever triptych poster for Eric Church can be seen on pages 166-167. It was created for the "Double Down" tour stop in Cincinnati, Ohio. Riverboat time! I wanted to create this as a huge nod to all the Clint Eastwood spaghetti westerns and the associated classic movie posters. Fans loved it; the triptychs sold out quickly.

The second triptych project was for one of our faves: Tedeschi Trucks Band - and this was their first ever triptych poster! They play a residency for 6 days at the Beacon in NYC every year, it is a much sought after ticket for all 3 nights. The triptych is printed full bleed so that all three posters can be framed/hung together as shown in the image (page 174-175).

The poster for my good friend Alan Mearns' (Yes The Raven) record release is one of many Alan has asked me to create over the years. Do yourself a favor and go listen to and support this great artist that should be a household name.

2020

In a word, 'UGH'. The Covid-19 pandemic made 2020 a lot of things, one of which was a year where bands had to stop touring and any live events came to a screeching halt. Personally, we lost a lot of business, several planned gig poster projects were of course canceled or postponed. It was tough emotionally to see good friends and clients have to stop doing what they love. I decided to reduce all studio creative rates when we did get to work with any musicians locally in Asheville and surrounding areas. I was happy to help design a few albums and matching promotional materials as well.

A lot of positive things came out of the challenges and dangers too...I took the unique opportunities of less work to finally get a print studio of sorts set up! I started a business called *The Silent Pine* (TheSilentPine.com), which is me printing by hand, mostly lino-cuts and block printing. It's been fun and my hope is to continue challenging myself creatively, regardless of what the world around me does.

I was invited to take part in 'Erase Covid - Artists Give Back' program, where hand picked poster artists donated designs to help spread the word to be safe and mask up, socially distance and wash your hands, etc. So many of our friends who are artists, designers, musicians, road crew, etc. just had their livelihoods wiped out for months and months. So a fund set up to provide direct help seemed like a perfect fit. They worked with the charity partner, MusiCares.

Poster Addendum

The few years since 2020 has allowed musicians once again to get back on the road and tour. I'm thankful to end the book on a high note - "Live music is BACK!"

The Wilco and Sleater Kinney poster art (page 200) has a weird coincidence to it. The original date had to be changed due to the pandemic, then the day before the new date is set to happen, Asheville gets near record breaking amounts of rain, thanks to the left overs from a hurricane that came through the area. The entire outdoor area at Salvage Station - which is located *right* next to the French Broad River - is now a pool. Talk of canceling the show (again) starts to happen, but thank goodness by the next day it had receded. Mushy no doubt, but at least the audience didn't need floaties to attend.

One highlight from this period is the poster for Wilco's 20th Anniversary celebration tour of *Yankee Hotel Foxtrot*, the album many regard as one of the band's finest (page 203). I'm always in great hands when I get to work with Dan MacAdam of Crosshair in Chicago.

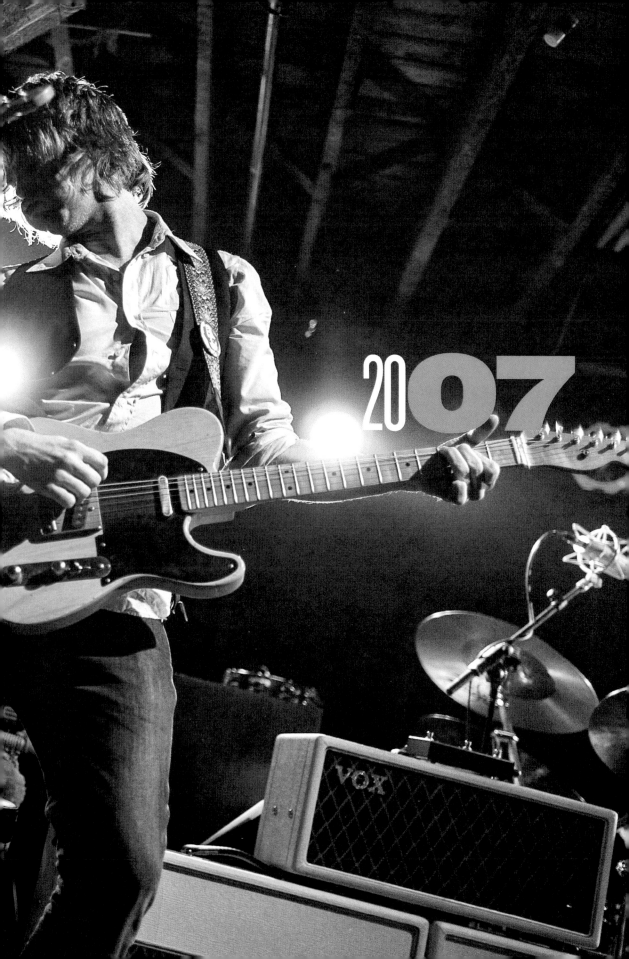

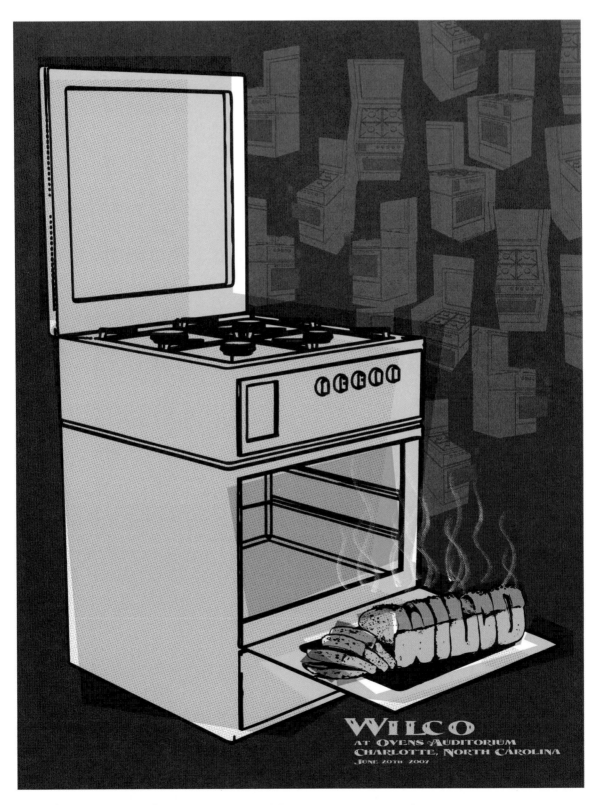

Wilco, Ovens Auditorium, 18 x 24 inches, five color screen print.

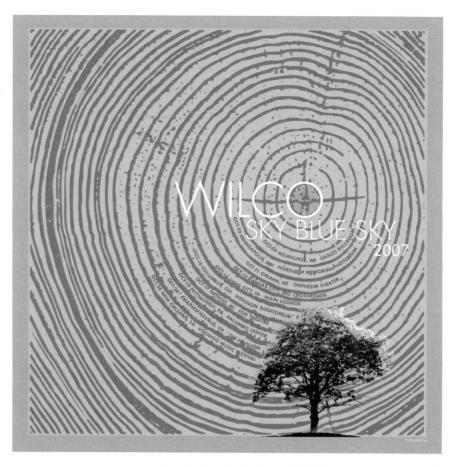

Wilco, Sky Blue Sky Tour Poster, 24 x 24 inches, four color screen print.

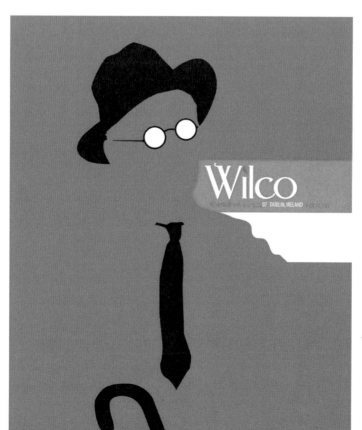

Wilco, Vicar Street, 18 x 24 inches, three color screen print.

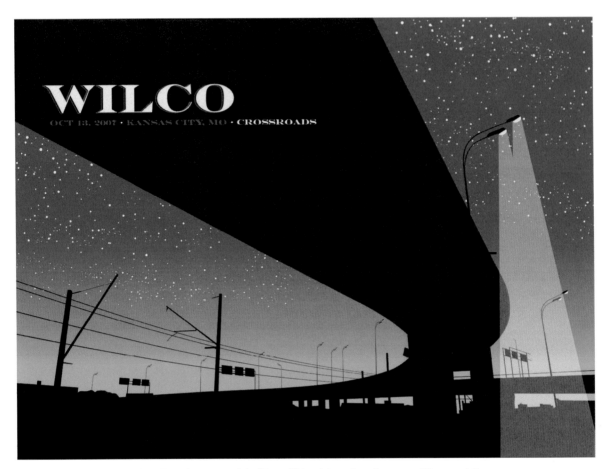

Wilco, Crossroads, 24 x 18 inches, five color screen print with a split fountain and semi-opaque white overprinting.

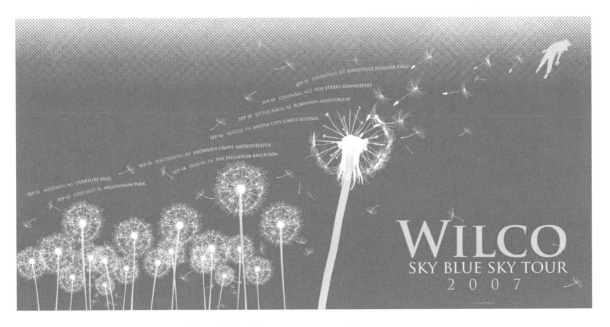

Wilco, Fall Tour Poster, 12 x 24 inches, two color screen print.

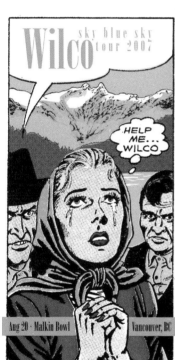

Wilco, Malkin Bowl,
18 x 36 inches, five color
screen print.

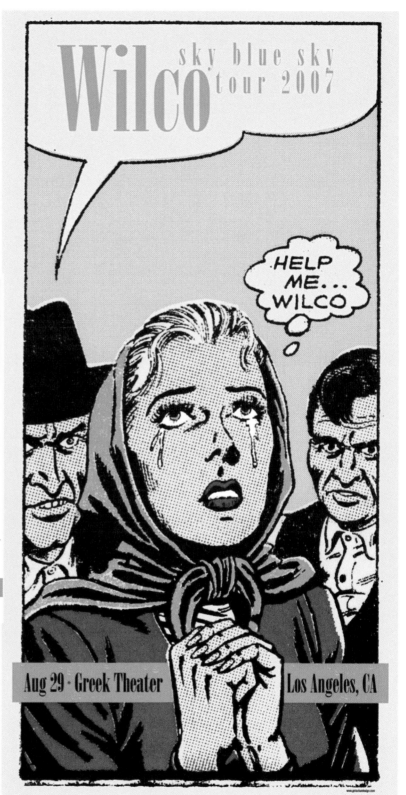

Wilco, Greek Theater, 18 x 36 inches, four color screen print on cream stock.

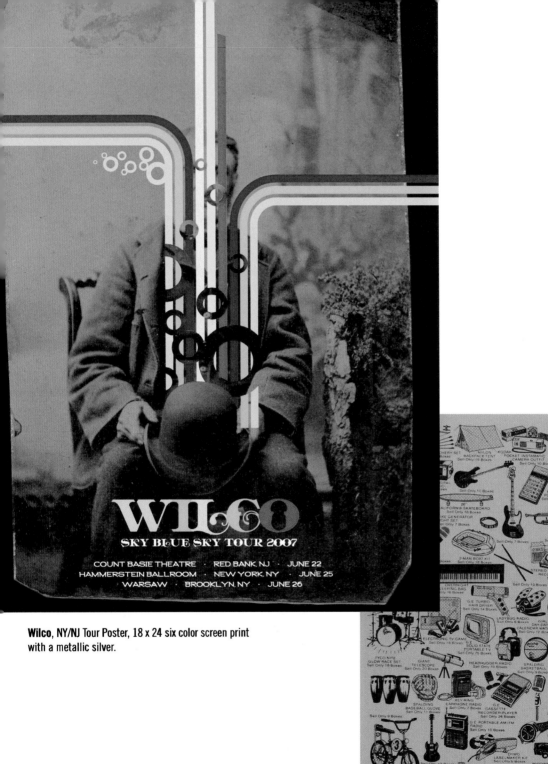

Wilco, NY/NJ Tour Poster, 18 x 24 six color screen print with a metallic silver.

Wilco, Sky Blue Sky Tour Aug/Sept, 12 x 24, two color screen print.

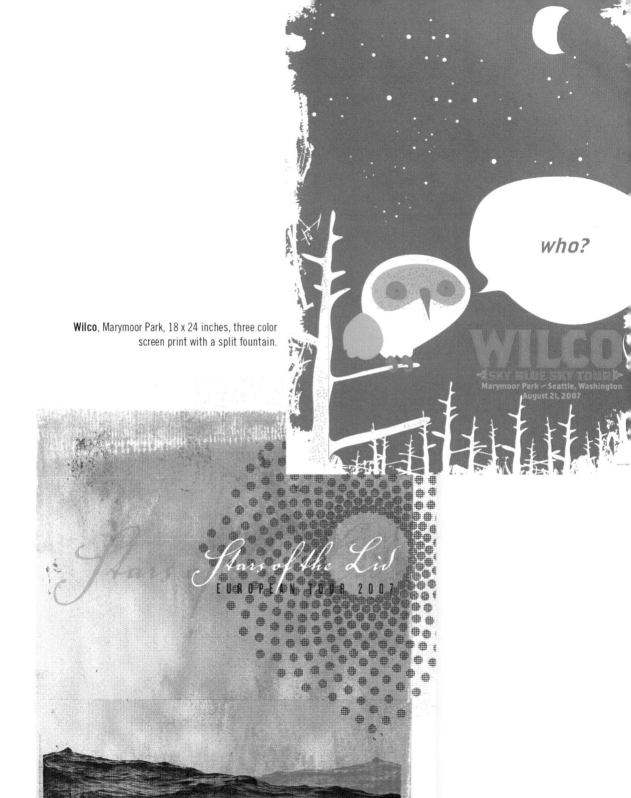

Wilco, Marymoor Park, 18 x 24 inches, three color screen print with a split fountain.

Stars of the Lid, European Tour, 18 x 24 four color screen print with overprint.

Winner of the "Gigposter of the Week" award.

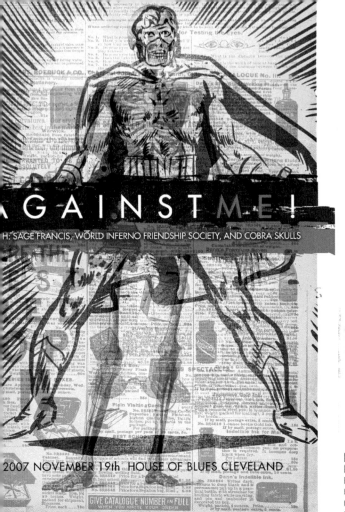

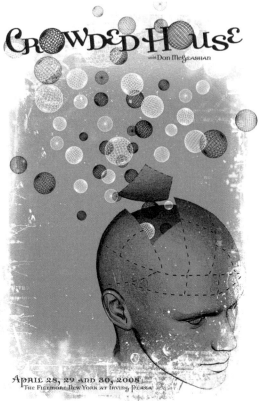

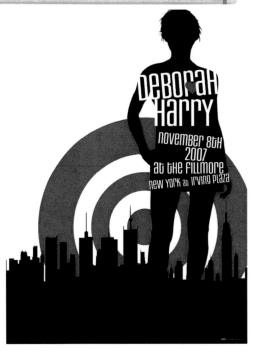

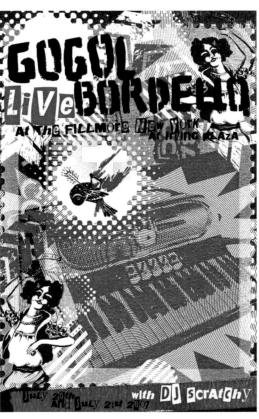

Top left: **Against Me!**, House of Blues, digital print on poster stock. Top right: **Crowded House**, The Filllmore, NYC, digital print on poster stock. Bottom left: **Debby Harry (Blondie)**, Fillmore NYC, digital print on poster stock. Bottom right: **Gogol Bordello**, The Fillmore, NYC, digital print on thick poster stock.

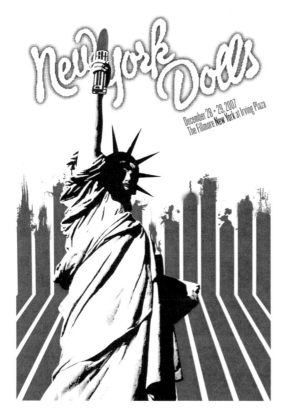

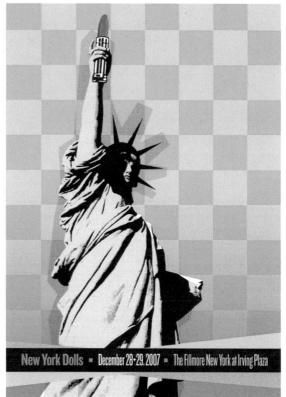

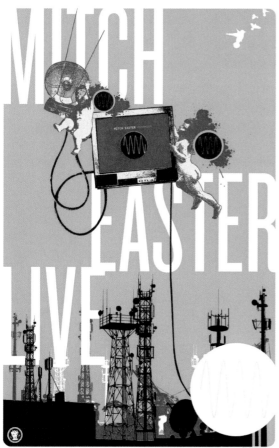

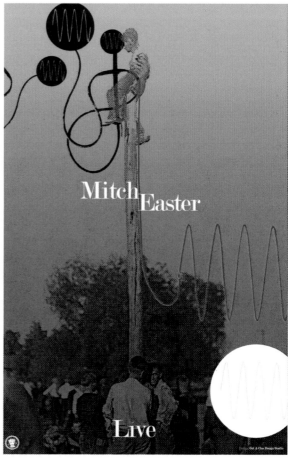

Top row: **New York Dolls**, The Fillmore, NYC, digital print on thick poster stock. Bottom row: **Mitch Easter**, General live poster, digital print on thick poster stock.

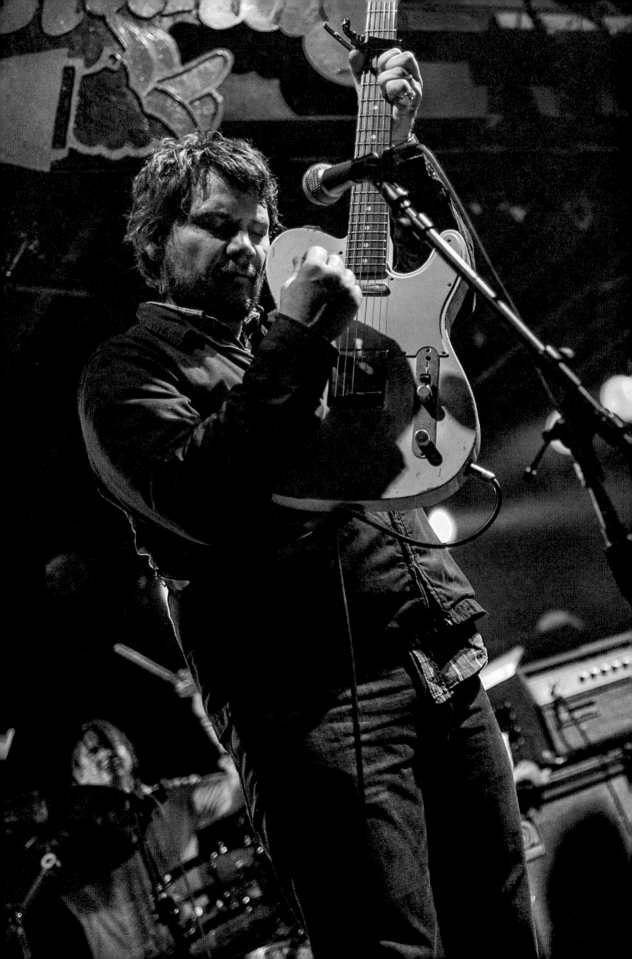

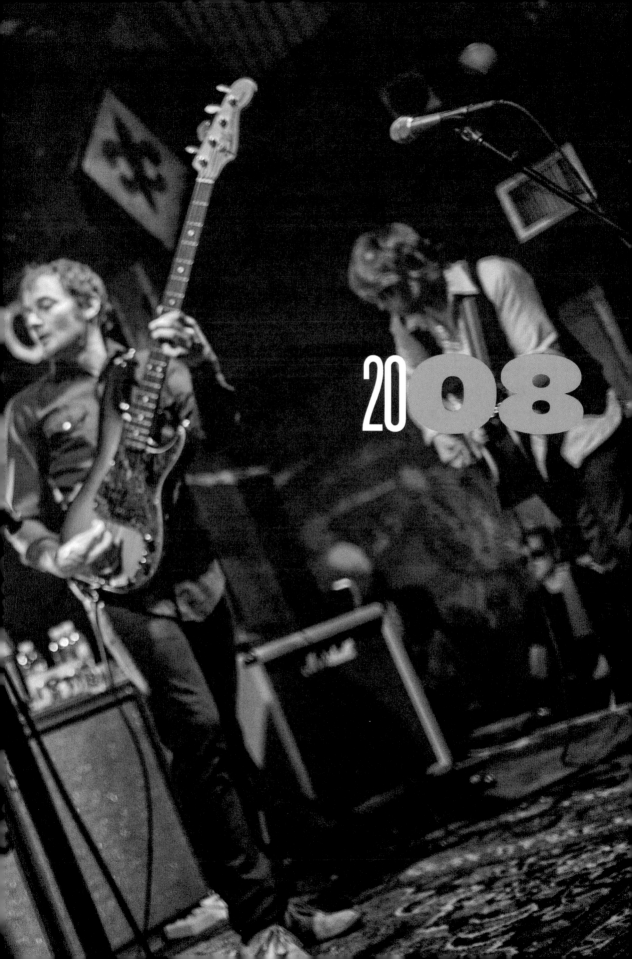

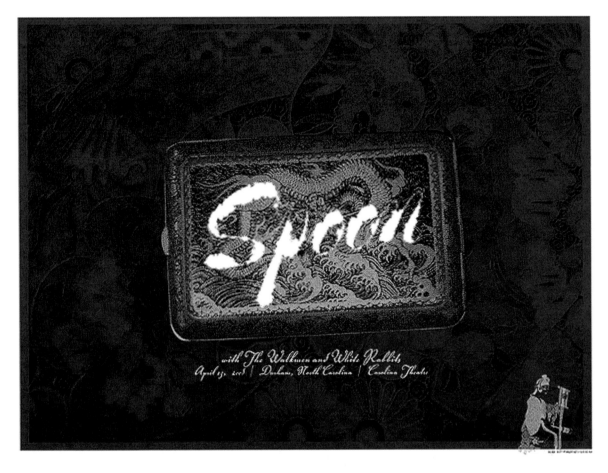

Spoon, Carolina Theatre, 24 x 18 three color screen print a gold metallic ink.

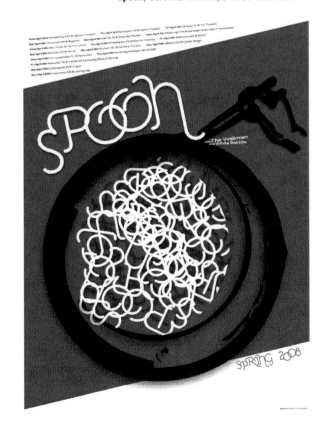

Spoon, Spring Tour Poster, 18 x 24 two color screen print.

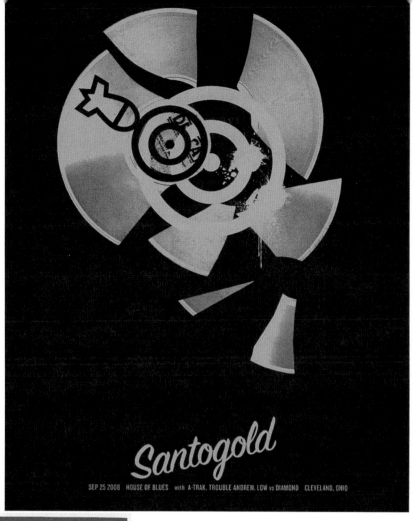

Santogold, House of Blues, 18 x 24, one color screen print with gold metallic on black stock.

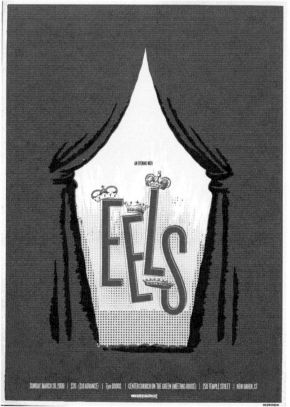

EELS, Meeting House, 14 x 18 three color screen print.

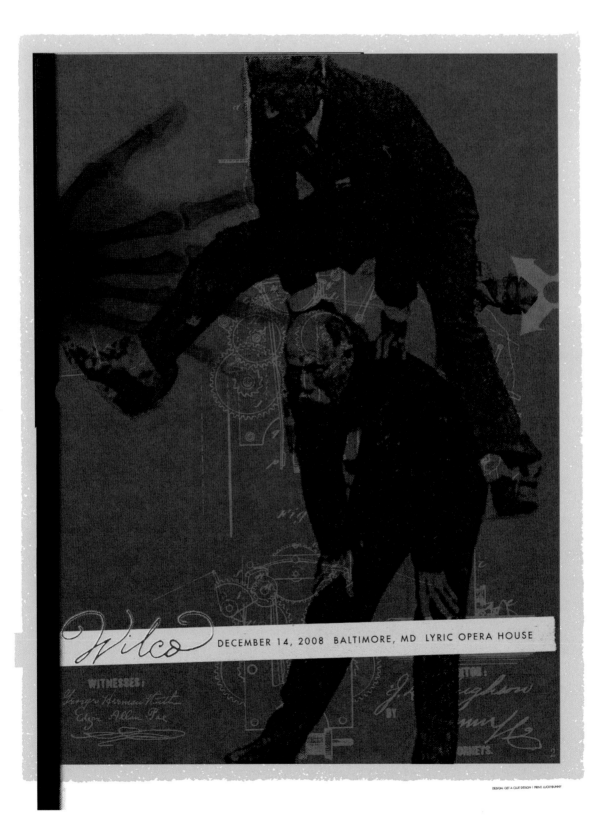

Wilco, Lyric Opera House, 18" x 24" three color screen print

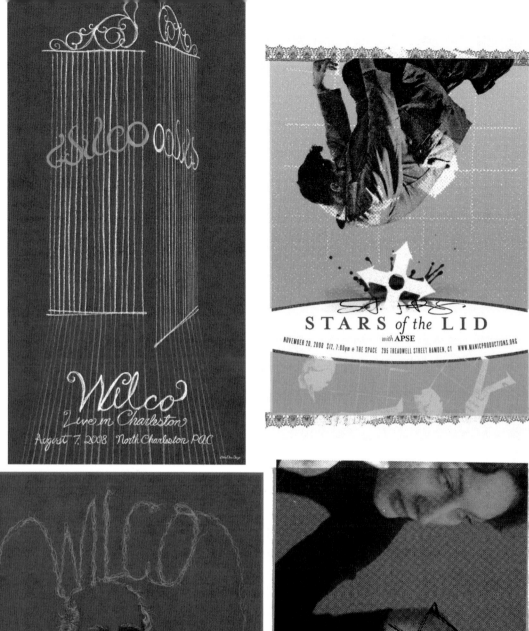

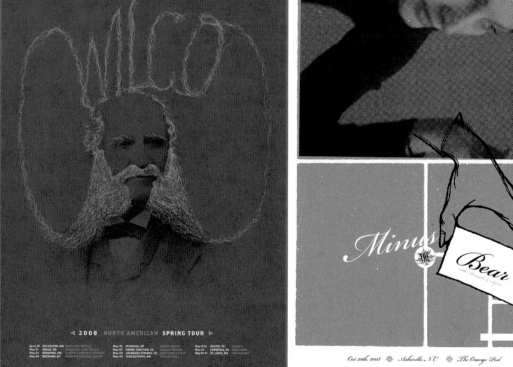

Top left: **Wilco**, N. Charleston PAC, 12 x 24, two color screen print on brown stock. Top right: **Stars of the Lid**, The Space, 18 x 24, three color screen print on cream stock. Bottom left: **Wilco**, Spring Tour Poster, 18 x 24, three color screen print. Bottom right: Minus The Bear, The Orange Peel, Asheville, NC, 18 x 24, on cream stock.

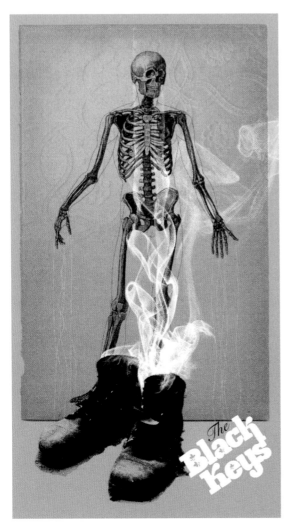

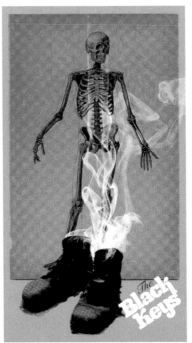

The Black Keys, The Orange Peel, 14 x 24,
three color screen print on specialty stock.

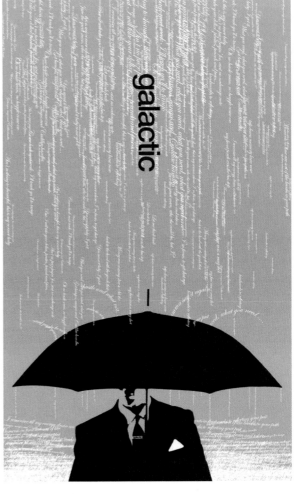

Galactic, general tour poster, 16 x 24, three color screen print
with a split fountain.

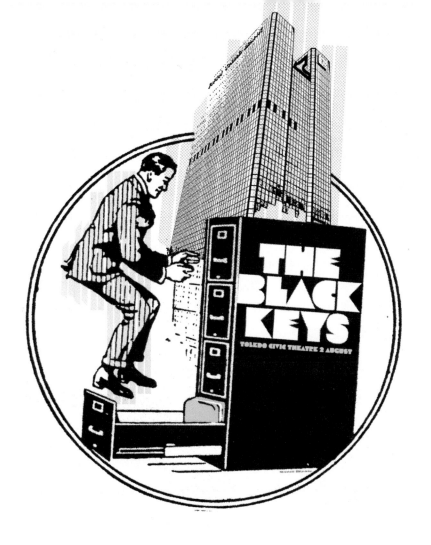

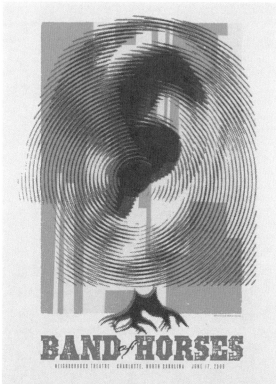

The Black Keys, Toledo Civic Theatre,
20 x 26, two color screen print on cream stock.

Band of Horses, Neighborhood Theatre,
18 x 24, three color screen print with
overprinting.

31

Wilco, Summer Tour Poster, 14 x 20,
three color screen print with overprint.

Wilco, Verizon Theater, 18 x 24, eight color screen print.

WILCO

HOUSTON. TEXAS. MARCH 7, 2008. VERIZON THEATER.

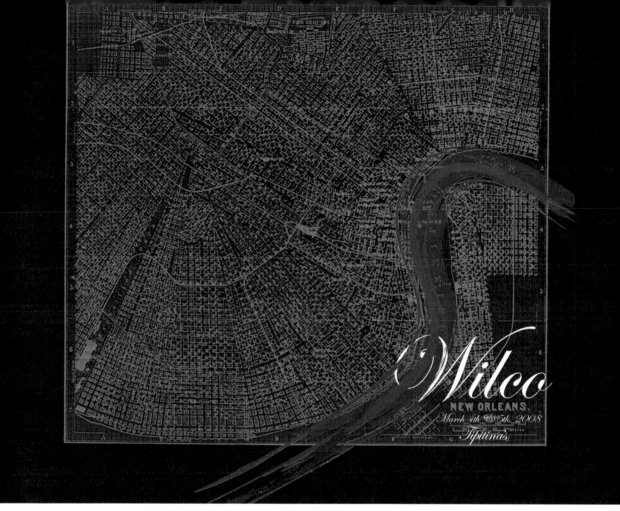

Wilco, Tipitina's, 20 x 20, three color screen print.

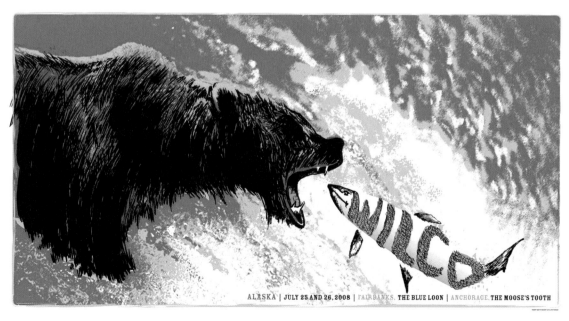

Wilco, The Blue Loon, 24 x 14, six color screen print.

20 09
FENDER

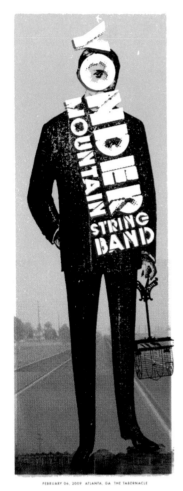

Yonder Mountain String Band,
The Fillmore, three color screen print.

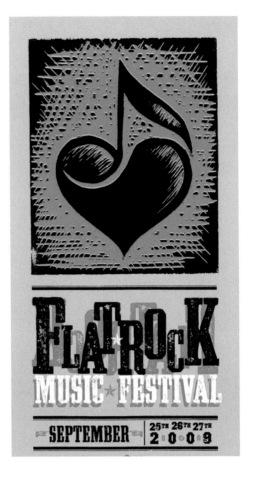

Flat Rock Music Festival, Camp Ton-A-Wandah, three
color screen print with spot white on specialty stock.

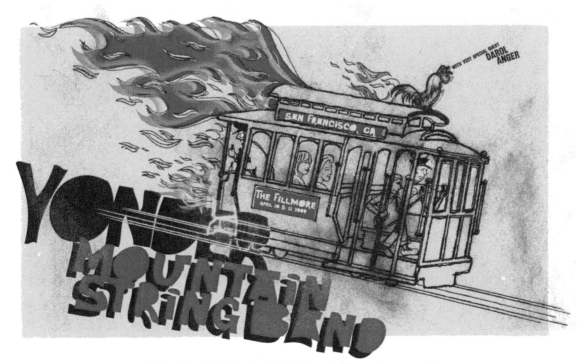

Yonder Mountain String Band, The Tabernacle, three color screen print.

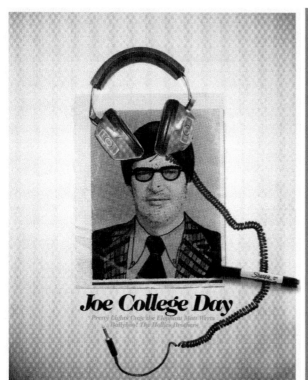
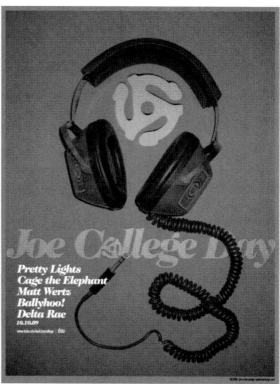

Joe College Day, Duke University, digital printing on poster stock.

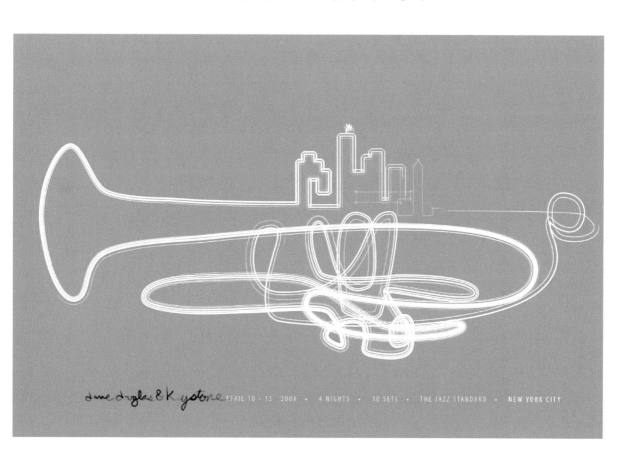

Dave Douglas, The Jazz Standard, two color screen print.

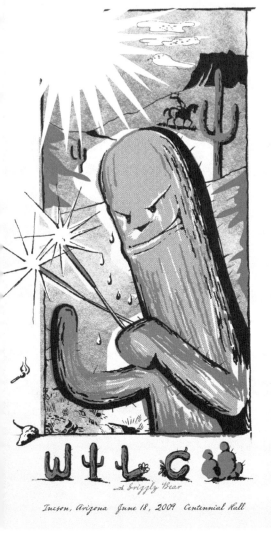

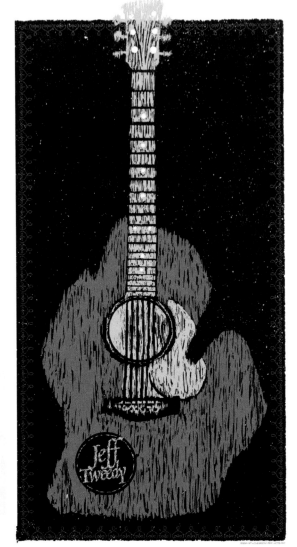

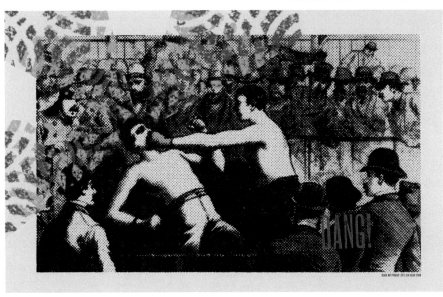

Top left, **Wilco**, Centennial Hall, 14 x 24, three color screen print with a spot white ink. Top right, **Jeff Tweedy**, State Theatre, 16 x 24, three color screen print. Bottom, **Dang!**, The Warehouse, 17 x 11, digital print on poster stock.

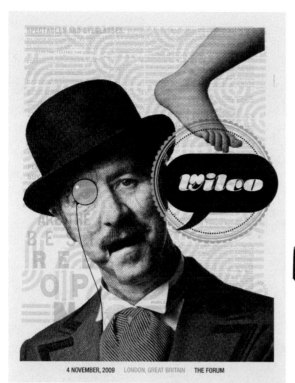

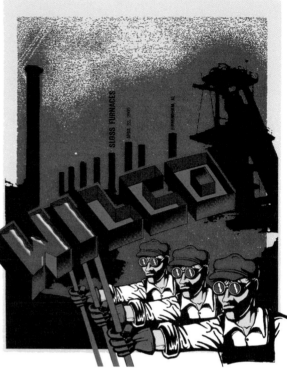

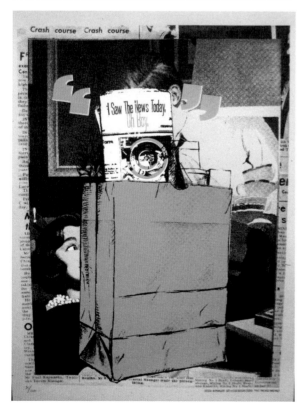

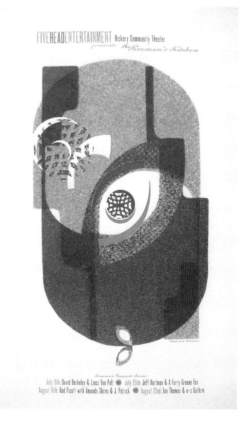

Top left, **Wilco**, The Forum, 18 x 24, three color screen print with overprinting on specialty stock. Top right, **Wilco**, Sloss Furnaces, 18 x 24, three color screen print. Bottom left, **"I Saw The News Today, Oh Boy"**, Art Print, 12 x 14, three color screen print on cream with spot white. Bottom right, **Five Head Entertainment**, The Fireman's Kitchen, 11 x 17 two color screen print.

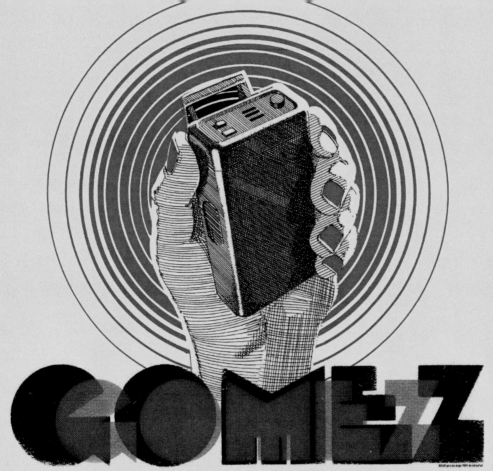

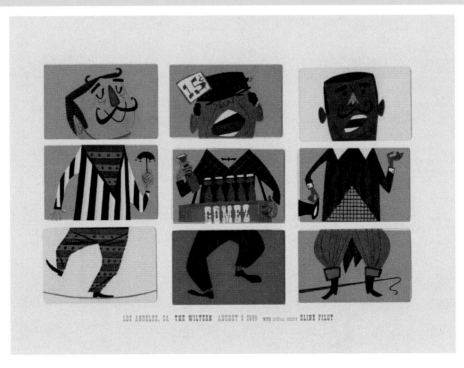

Gomez, The Wiltern, 18 x 18, three color screen print on specialty stock.
Gomez, The Fillmore, 24 x 18, two color screen print on specialty stock.

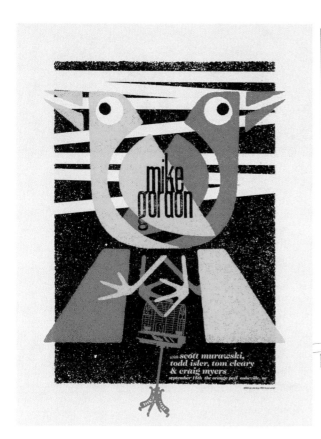

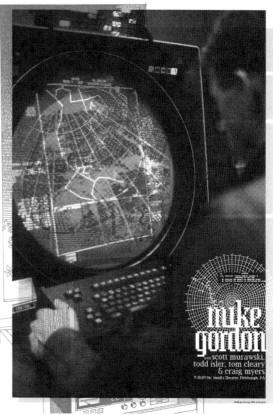

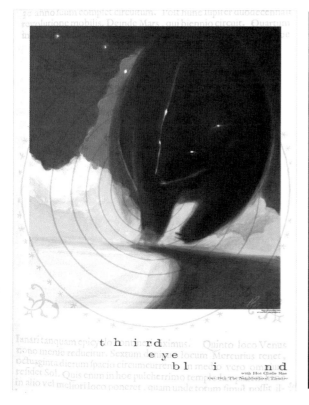

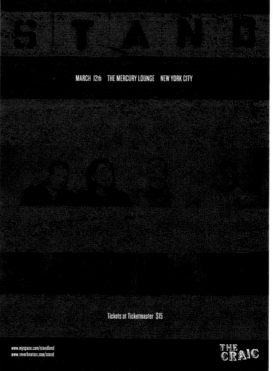

Top left, **Mike Gordon**, The Orange Peel, 18 x 24, three color screen print on specialty stock. Top right, **Mike Gordon**, Mr. Small's Theatre, three color screen print. Bottom left, **Third Eye Blind**, Neighborhood Theatre, digital print on poster stock. Bottom right, **Stand**, The Mercury Lounge, digital print on poster stock.

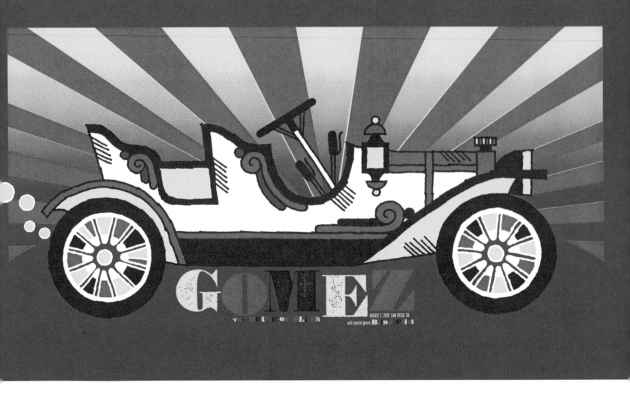

Gomez, The House of Blues, four color screen print.

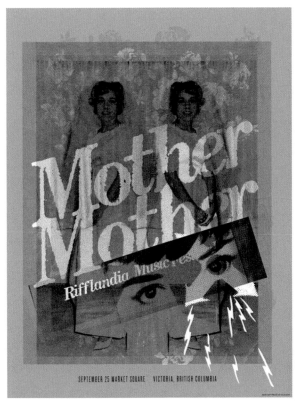

Mother Mother, Market Square, three color screen print on silver stock.

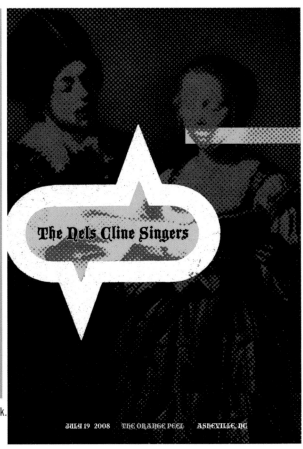

The Nels Cline Singers, The Orange Peel, digital print on poster stock.

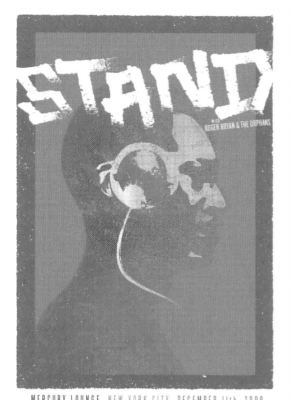

MERCURY LOUNGE NEW YORK CITY DECEMBER 11th 2008

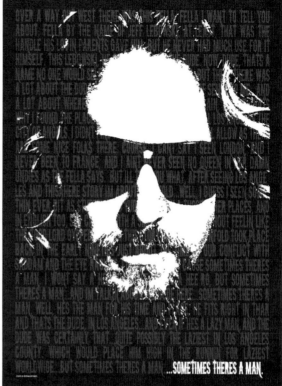

...SOMETIMES THERES A MAN.

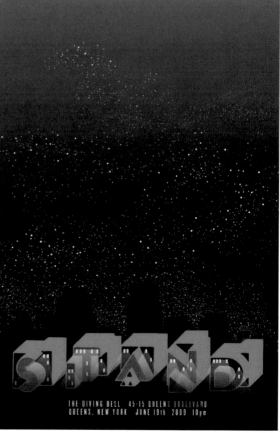

Top left, **Stand**, Mercury Lounge, digital print on poster stock. Top right, **"Sometime's There's A Man**, Art Print, spot white and silver metallic on black stock. Bottom left, **Stand**, Mercury Lounge, digital print on poster stock, bottom right, **Stand**, The Diving Bell, digital print on poster stock.

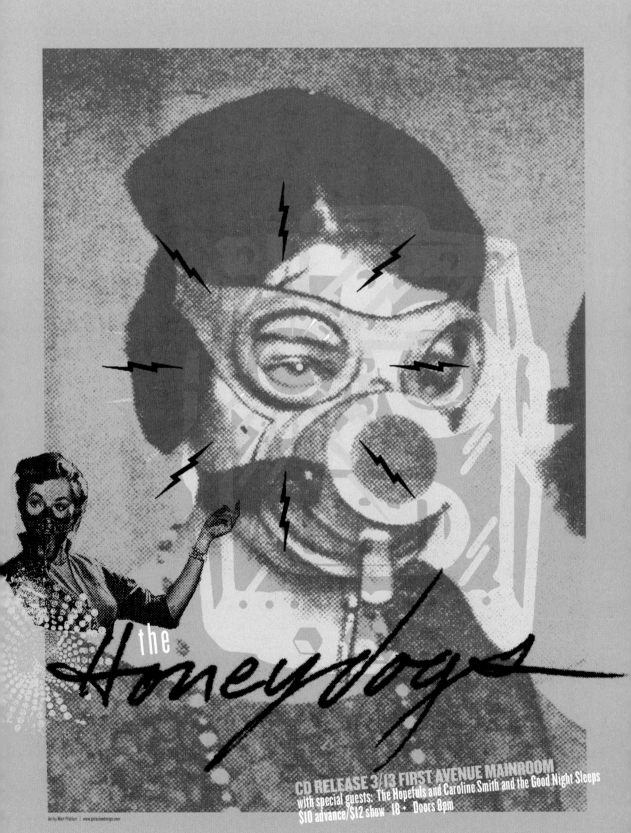

the Honeydogs

CD RELEASE 3/13 FIRST AVENUE MAINROOM
with special guests: The Hopefuls and Caroline Smith and the Good Night Sleeps
$10 advance/$12 show 18+ Doors 8pm

Art by Matt Pfahlert | www.getaclamdesign.com

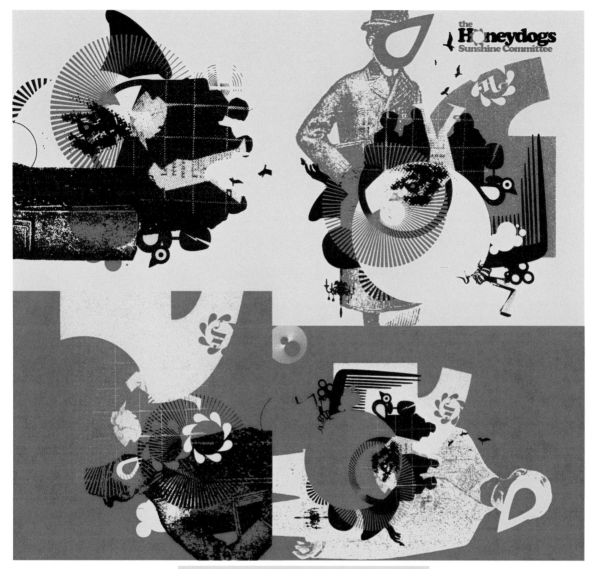

The Honeydogs, Album Release concert, digital print on poster stock.

Opposite page, **The Honeydogs**, First Avenue, digital print on poster stock.

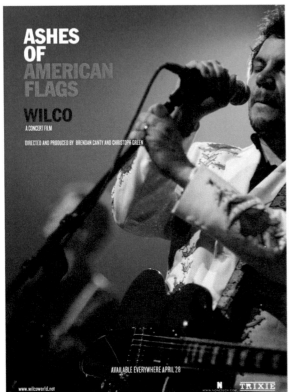
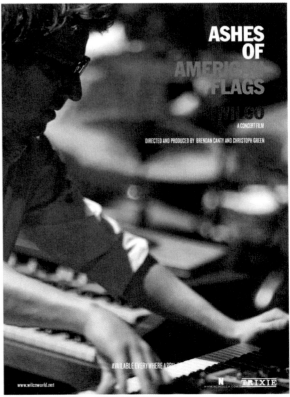
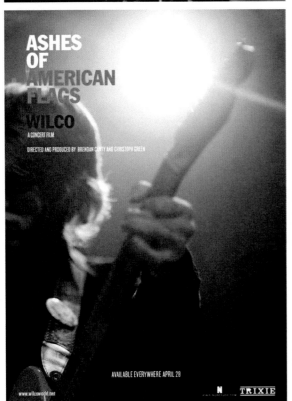
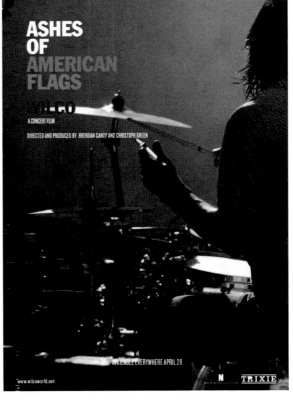

Wilco, Promotional Poster for "Ashes of American Flags", digital print on poster stock.
Photography: Zoran Orlic.

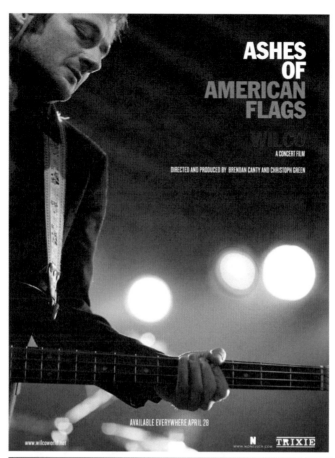

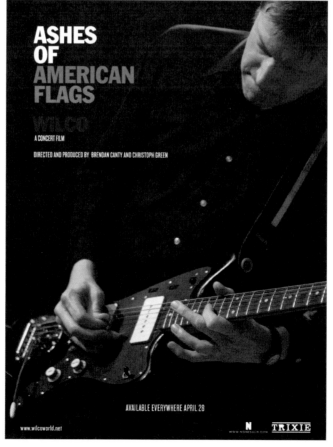

2010

Modest Mouse, The Orange Peel, 24 x 18, three color screen print (one metallic silver).

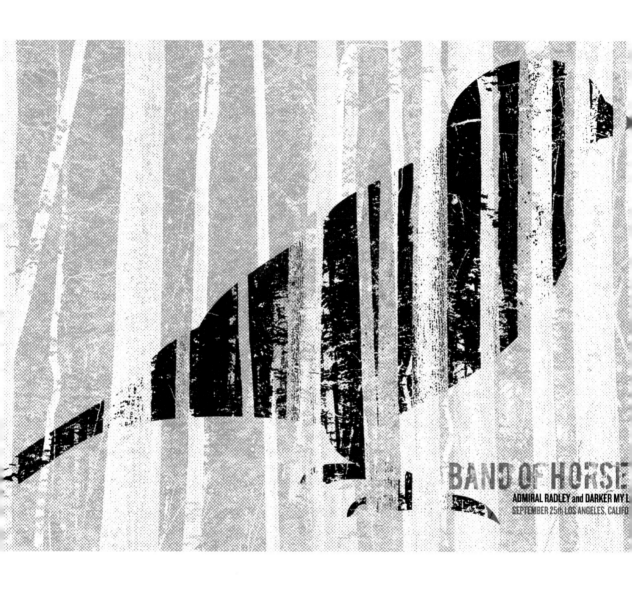

Band of Horses, Los Angeles, 24 x 18, three color screen print.

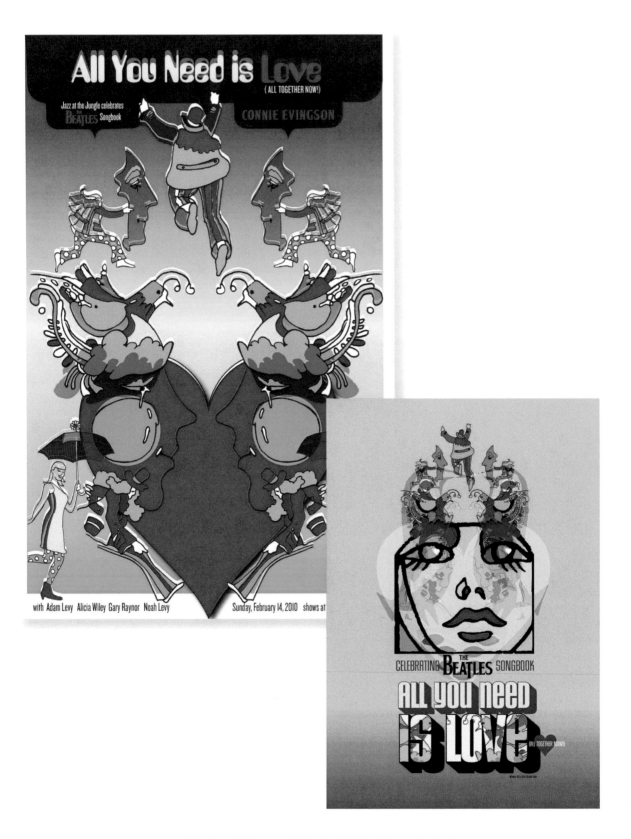

All You Need Is Love, Jungle Theatre, digital print on poster stock.

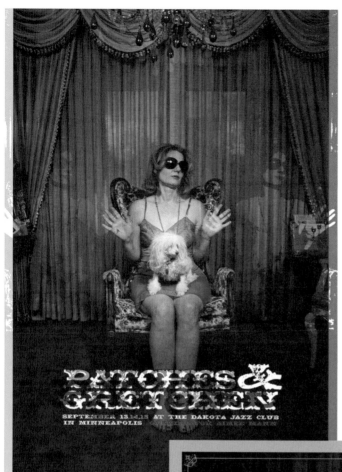

Patches & Gretchen, Dakota Jazz Club, digital print on poster stock.

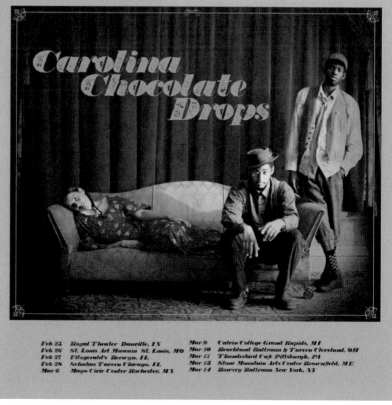

Carolina Chocolate Drops, digital print on poster stock.

Jon Lindsay, digital print on thick poster stock.

Storyhill, general promo poster, digital print on poster stock.

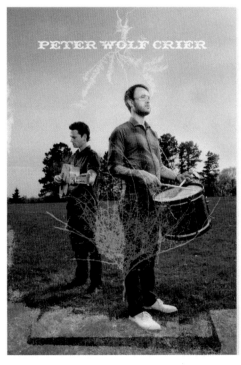

Peter Wolf Crier, general promo poster, digital print on poster stock.

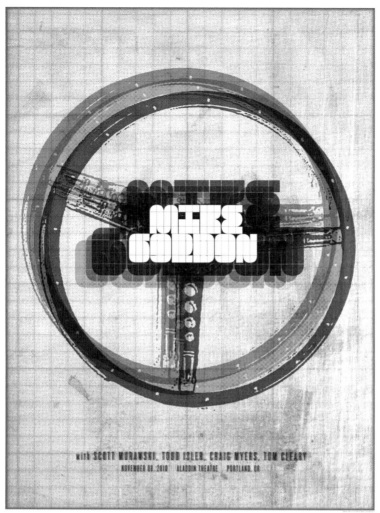

Mike Gordon, Something Theatre, three color screen print.

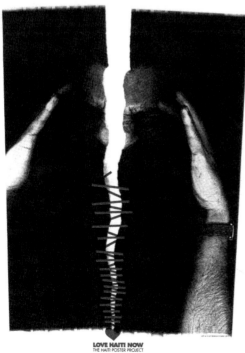

Love Haiti Now, digital color on poster stock.

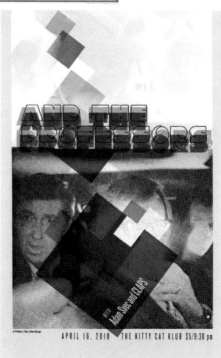

And The Professors, The Kitty Cat Club, digital print on poster stock.

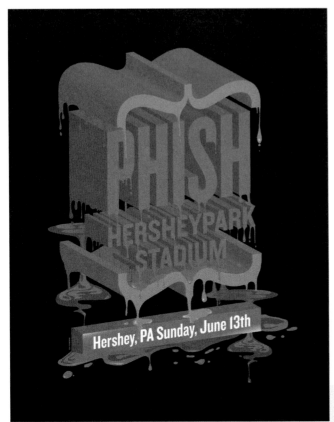

Phish, general promo poster, digital print on thick poster stock.

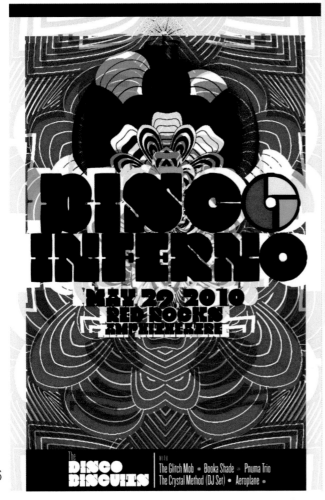

Big Head Todd and the Monsters, Red Rocks Amphitheater, three color screen print on cream stock.

The Disco Biscuits, Red Rocks Amphitheater, four color screen print.

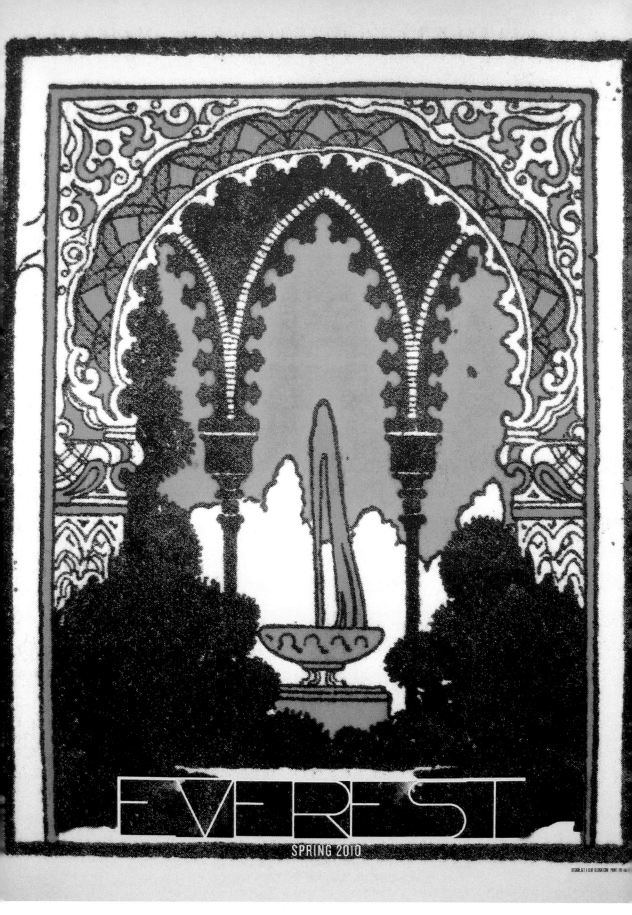

Everest, Spring Tour Poster, 18 x 24, three color screen print on French specialty poster stock.

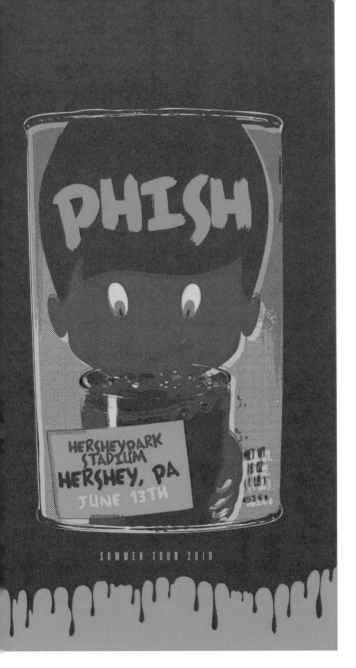

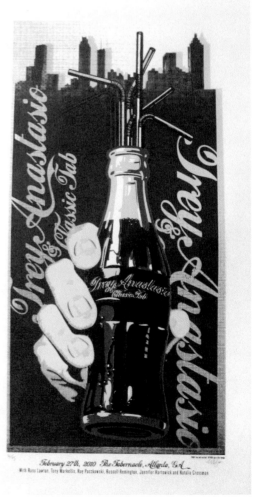

Phish, Hershey Park Stadium, three color screen print on French Paper specialty poster stock.
Trey Anastasio, The Tabernacle, four color screen print.

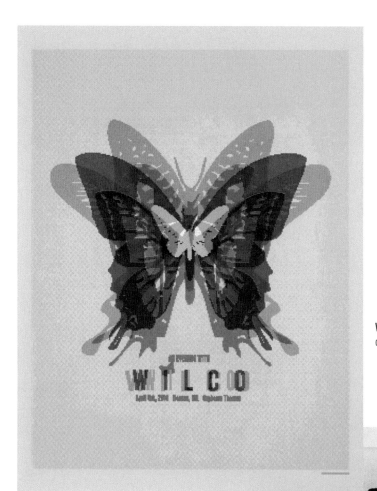

Wilco, Orpheum Theatre four color screen print with overprints on specialty French Paper poster stock.

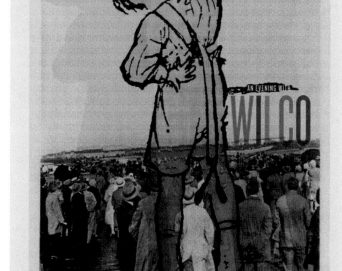

Wilco, Durham Performing Arts Center,
four color on specialty silver poster stock.

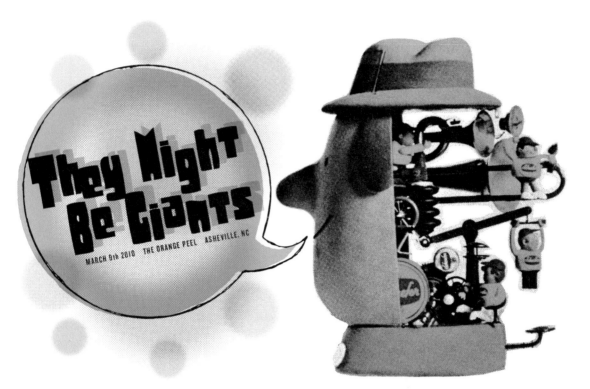

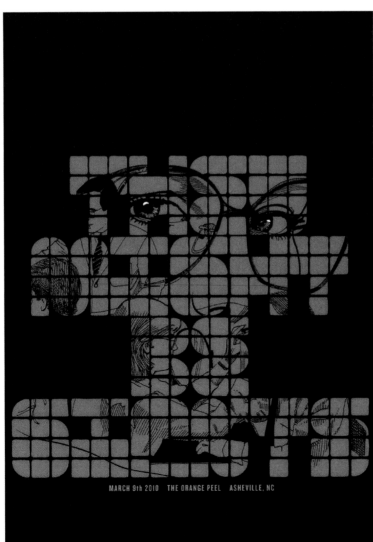

They Might Be Giants, The Orange Peel,
digital print on thick poster stock.

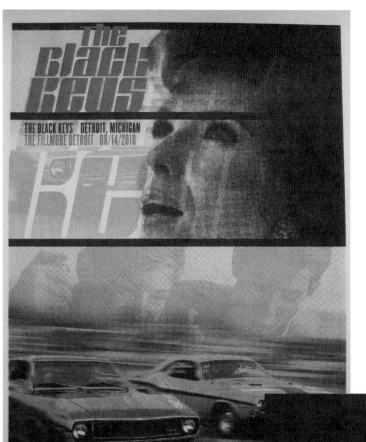

The Black Keys, The Fillmore Detroit, three color screen print on French Paper specialty stock.

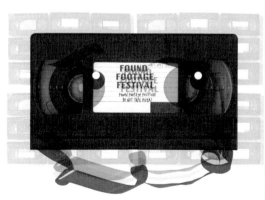

Found Footage Festival, general promo poster, digital print on poster stock.

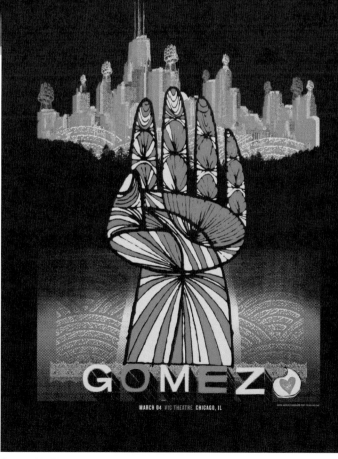

Gomez, Vic Theatre, two color on black stock.

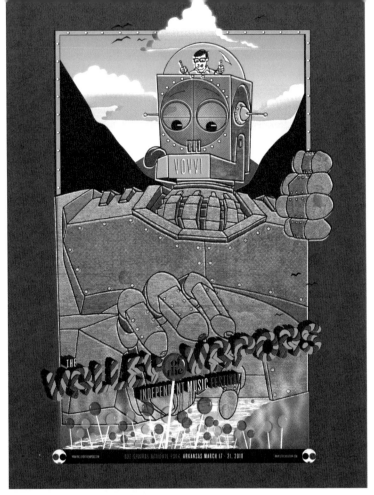

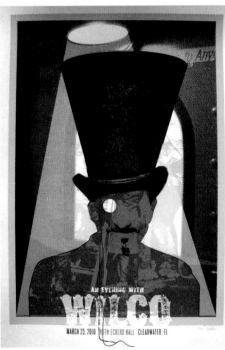

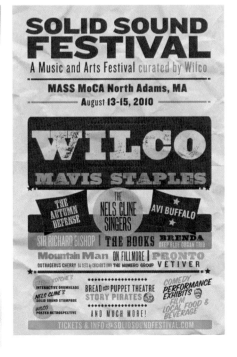

Top: **The Valley of the Vapors**, Hot Springs National Park, five color screen print on dark grey stock. Bottom left: **Wilco**, Ruth Eckerd Hall, three color screen print with overprints. Bottom right: **Solid Sound Festival**, MASS MoCA, digital print on poster stock.

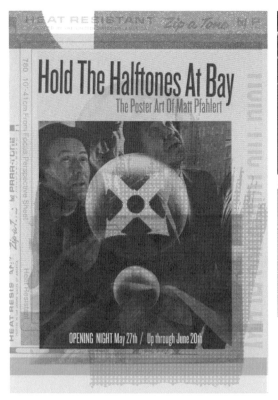

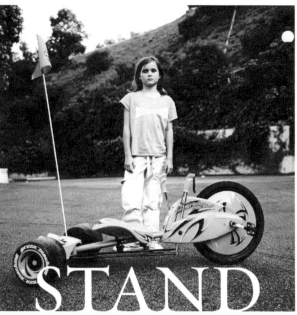

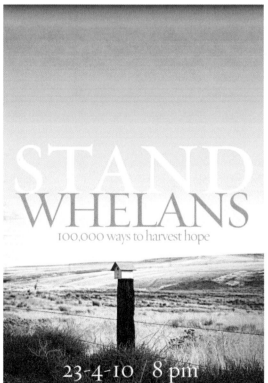

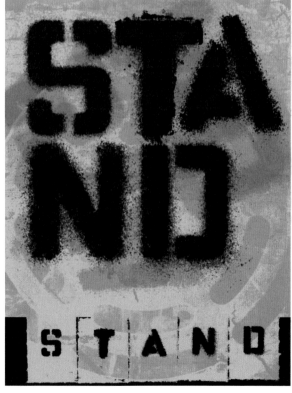

Top left: **Hold The Halftones At Bay**, Screaming Sky Gallery, digital color on poster stock. Top right: **Stand**, Whelans, digital print on poster stock. Bottom left: **Stand**, Whelans, digital print on poster stock. Bottom right: **Stand**, general tour poster, digital print on poster stock.

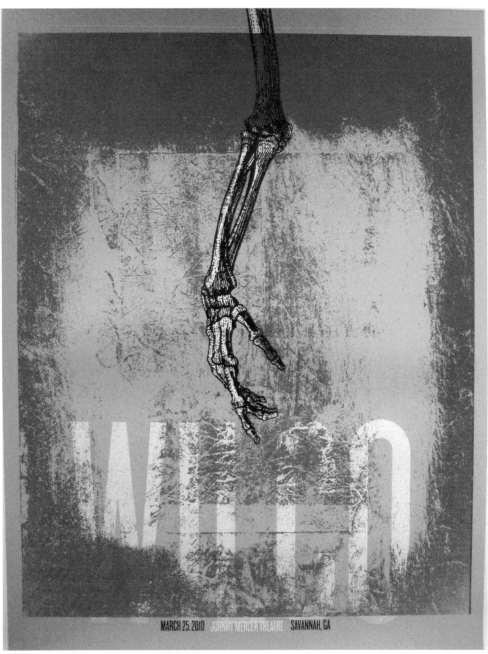

Wilco, Johnny Mercer Theatre, 18 x 24, three color screen print.

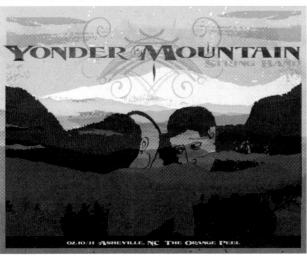

Yonder Mountain String Band, general promo poster, digital print on poster stock.

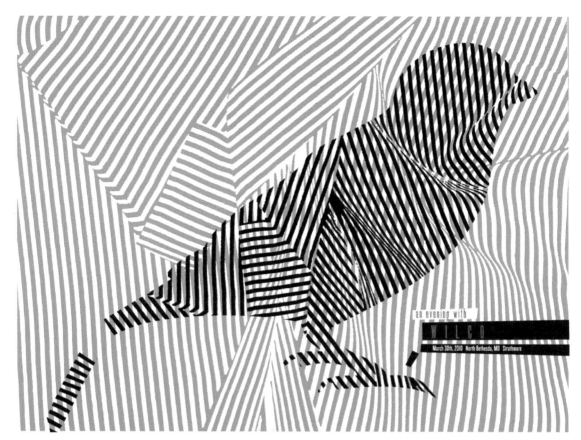

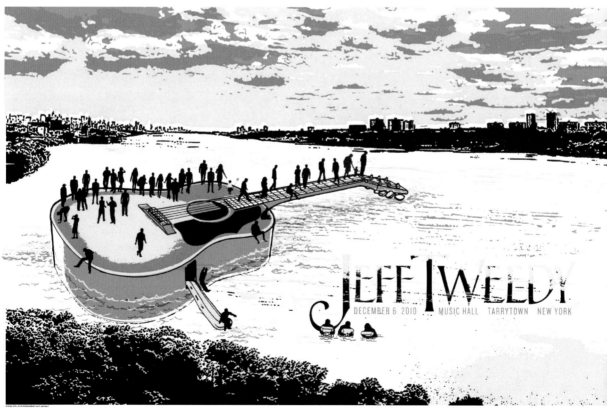

Wilco, Strathmore, 24 x 18, three color screen print with metallic silver.
Jeff Tweedy, Music Hall, 24 x 18, three color screen print with silver metallic ink.

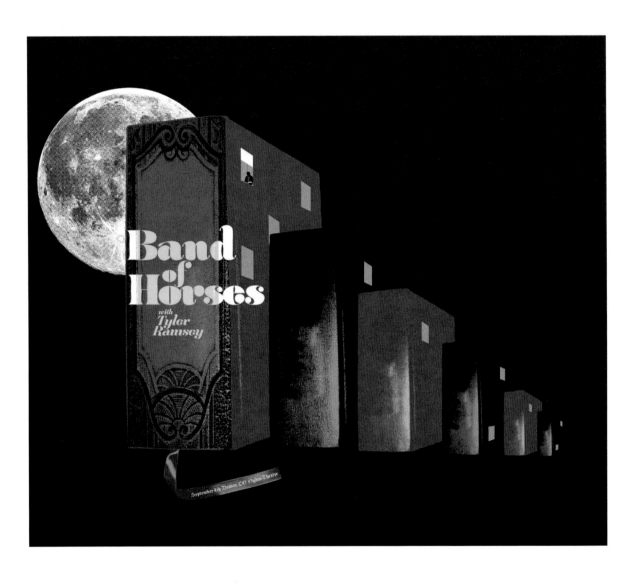

Band of Horses, Ogden Theatre, four color screen print on black stock with spot white inks.

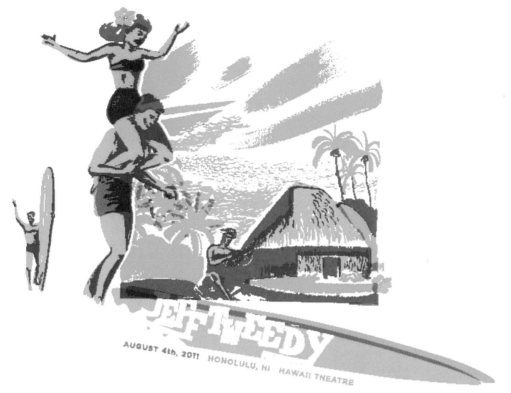

Jeff Tweedy, Hawaii Theatre, three color screen print.

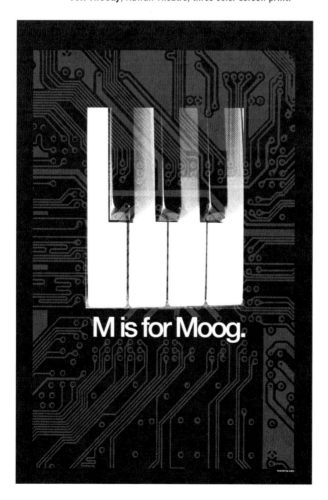

M is for Moog, art print, two
color screen print in black stock
with green metallic ink.

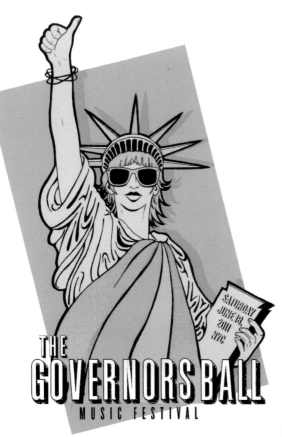

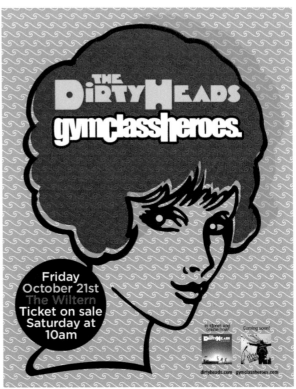

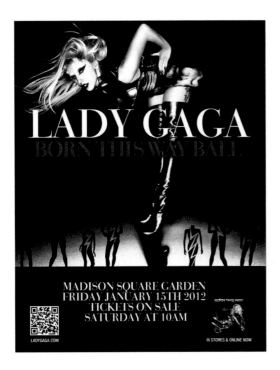

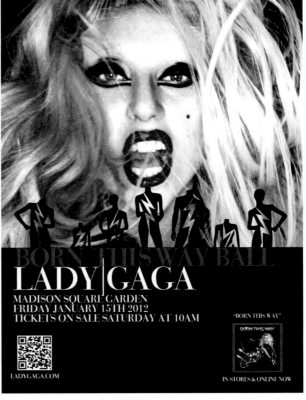

Top left: **The Governors Ball**, Governor's Island, digital color on poster stock. Top right: **The Dirty Heads**, The Wiltern, digital color on poster stock. Bottom row: **Lady Gaga**, Madison Square Garden, digital color on poster stock.

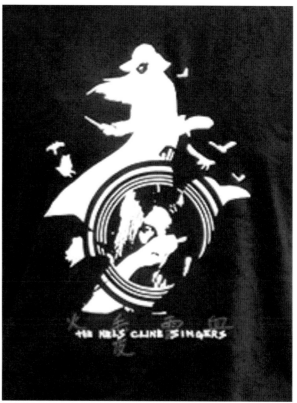

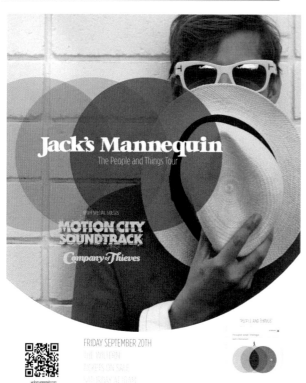

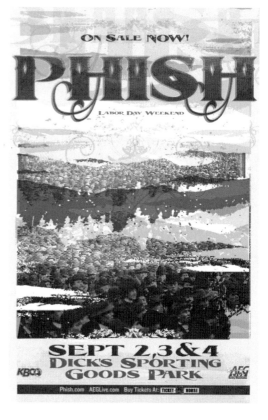

Top left: **Chris Velan,** tour poster, digital color on poster stock. Top right: **The Nels Cline Singers**, general tour poster, digital color on poster stock. Bottom left: **Jack's Mannequin**, The Wiltern, digital color on poster stock. Bottom right: **Phish**, Dick's Sporting Goods Park, digital color on poster stock.

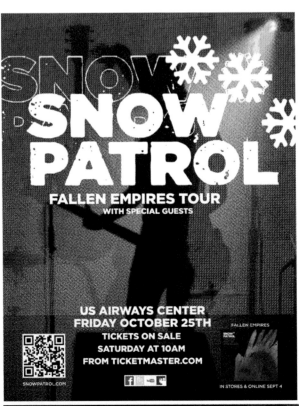

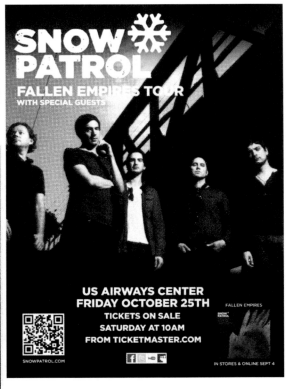

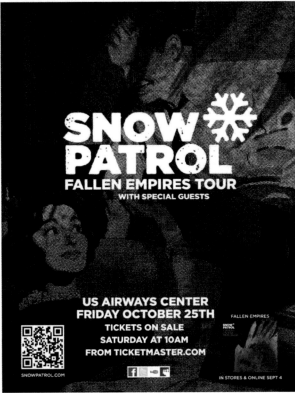

Snow Patrol, tour posters, digital color on poster stock.

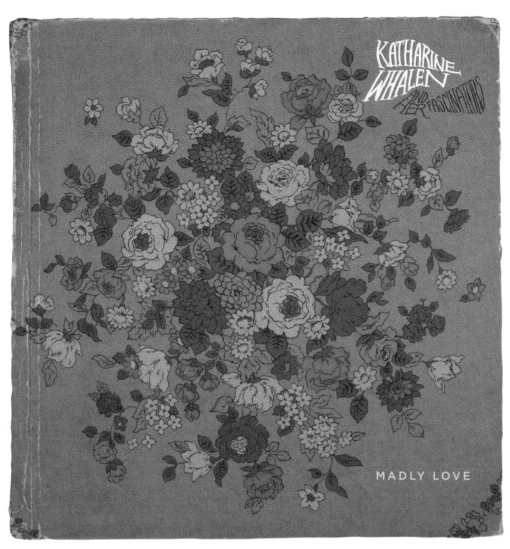

MADLY LOVE

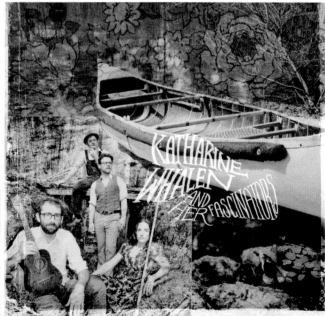

Katharine Whalen, tour poster,
digital color on poster stock.

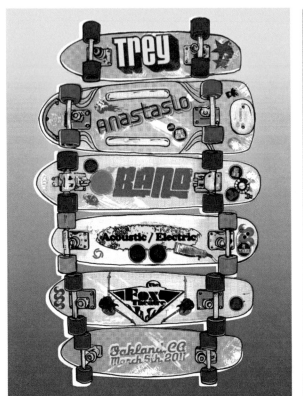
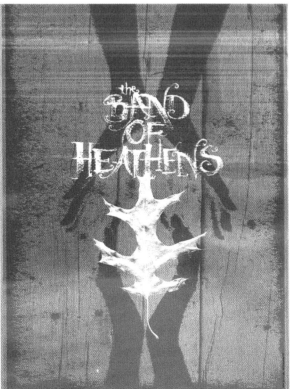
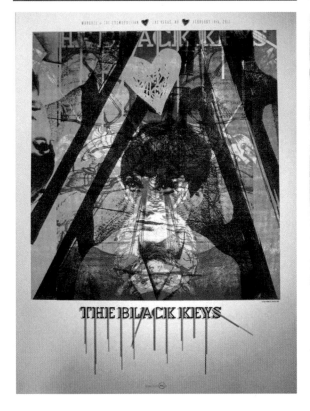
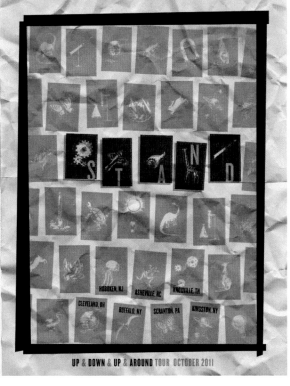

Top left: **Trey Anastasio**, Fox Theatre, five color screen print with split fountain. Top right: **Band of Heathens**, general tour poster, two color screen print. Bottom left: **The Black Keys**, Las Vegas special event poster, three color screen print on specialty metallic silver poster stock. Bottom right: **Stand**, October Tour Poster, two color screen print on cream stock.

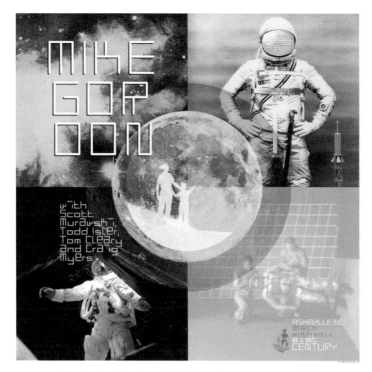

Mike Gordon, The Orange Peel, four color process screen print.

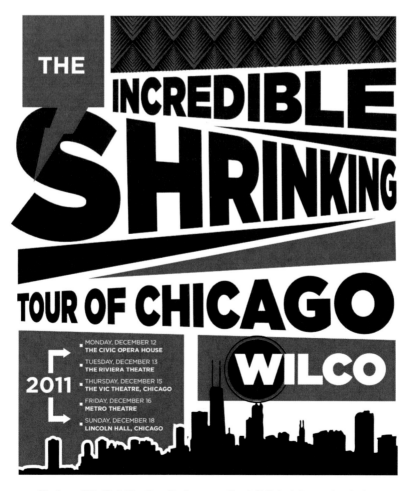

The Incredible Shrinking Tour Poster, promotional digital print on poster stock.

Wilco's "The Incredible Shrinking Tour"

1. Wilco at Civic Opera House, Chicago
2. Wilco at The Riviera, Chicago
3. Wilco at The Vic Theatre, Chicago
4. Wilco at Metro, Chicago
5. Wilco at Lincoln Hall, Chicago

Three color screen print on French Paper's Construction Paver Red poster stock. Each poster has red flocking, the red felt like material seen in each poster's pattern area (see detail shots). Each poster was also printed with gold metallic ink and a double hit of white ink. Printed by Dan Macadam at Crosshair. Designed by Matt Pfahlert & Bill Mooney /D.R. Sapperstein.

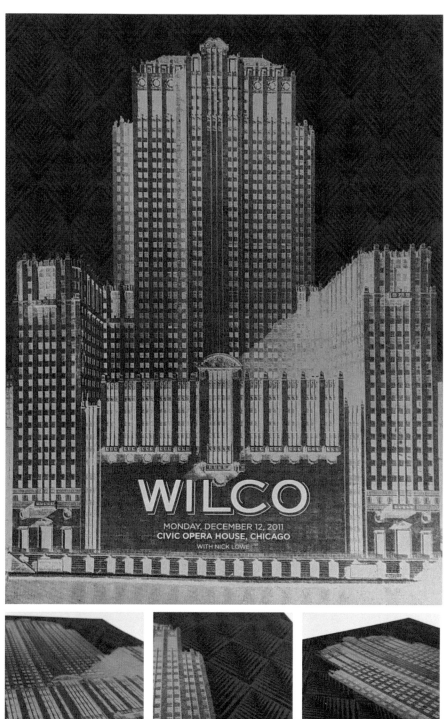

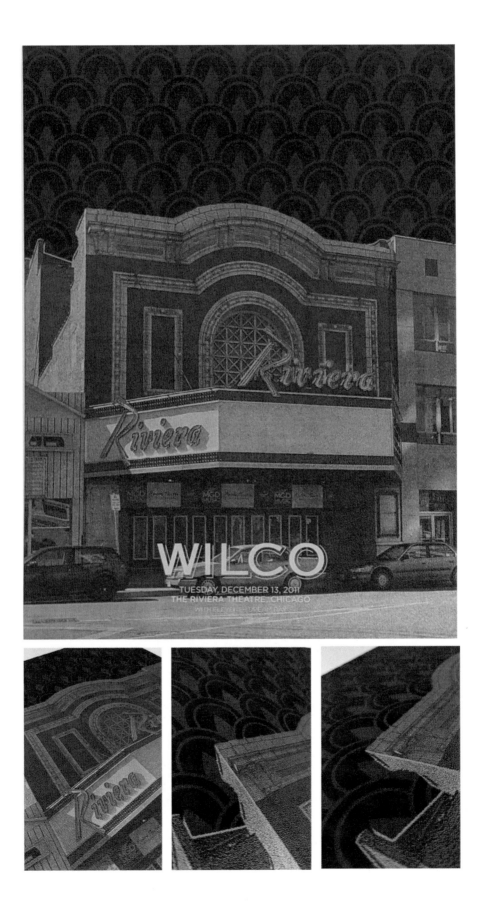

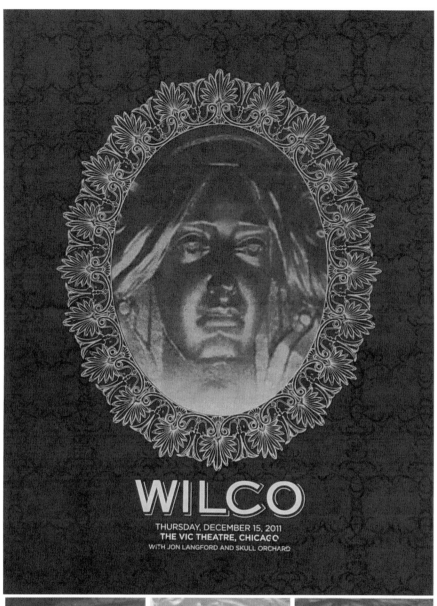

WILCO

THURSDAY, DECEMBER 15, 2011
THE VIC THEATRE, CHICAGO
WITH JON LANGFORD AND SKULL ORCHARD

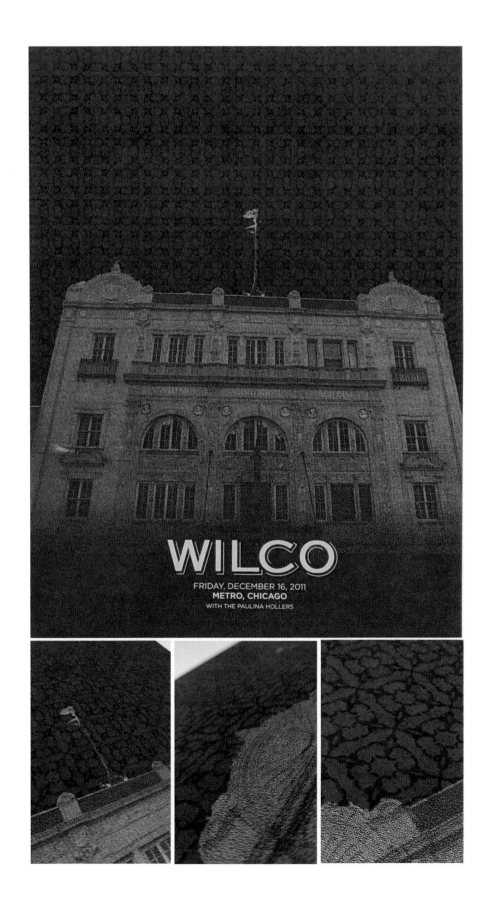

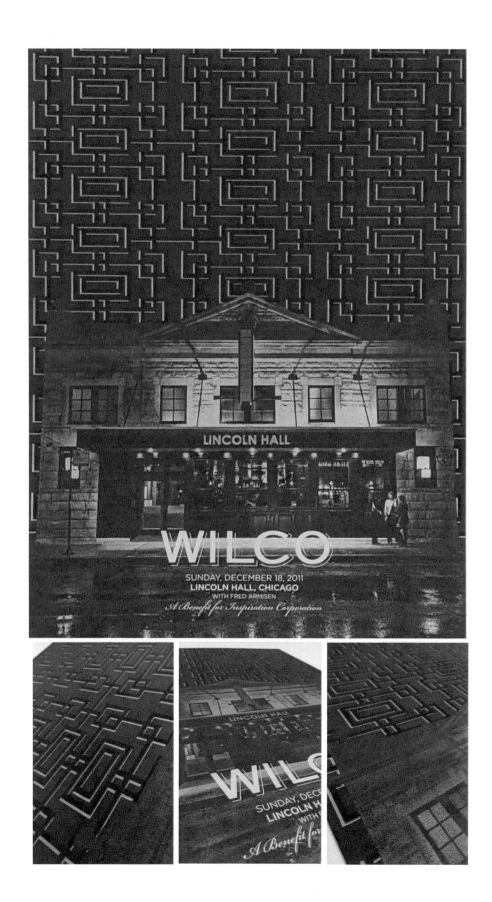

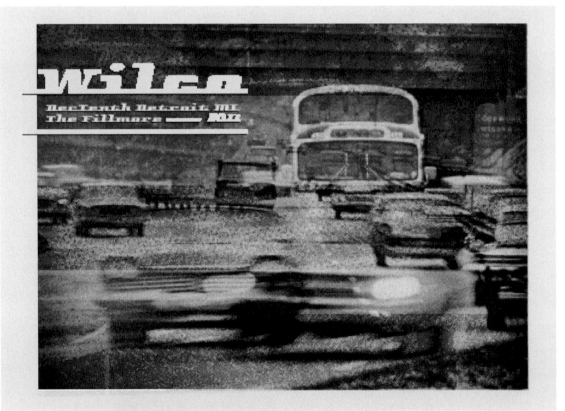

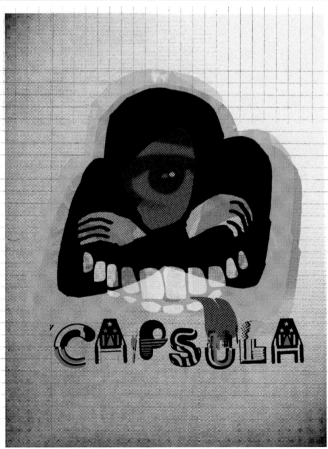

Wilco, The Fillmore Detroit, 24 x 18, four color process screen print on specialty French Paper poster stock.
Capsula, general tour poster, 18 x 24, three color screen print on cream stock.

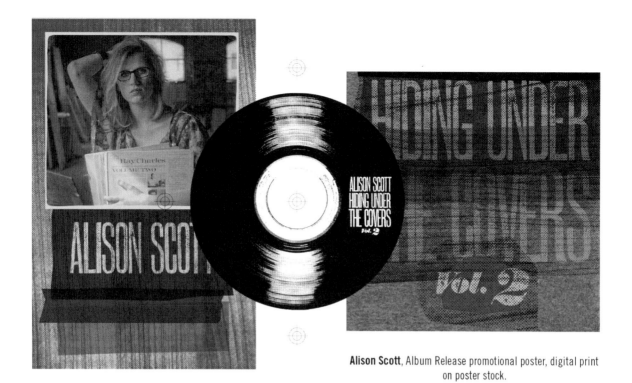

Alison Scott, Album Release promotional poster, digital print on poster stock.

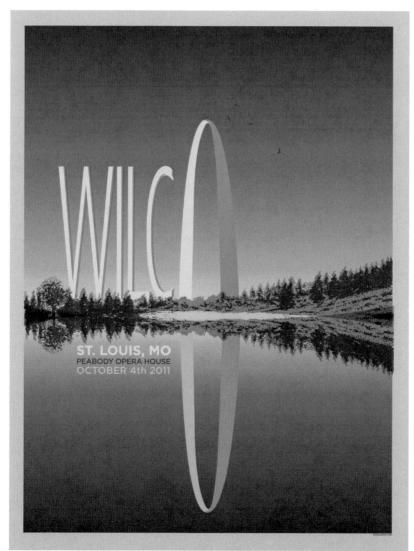

Wilco, Peabody Opera House, five color screen print with silver metallic ink.

20**12**

S FINEST ROCK

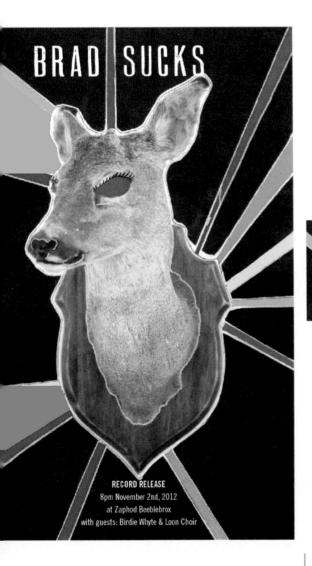

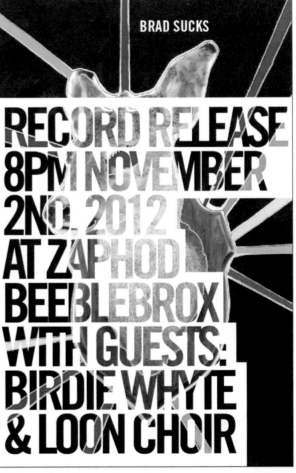

Brad Sucks, record release poster, digital color on poster stock.

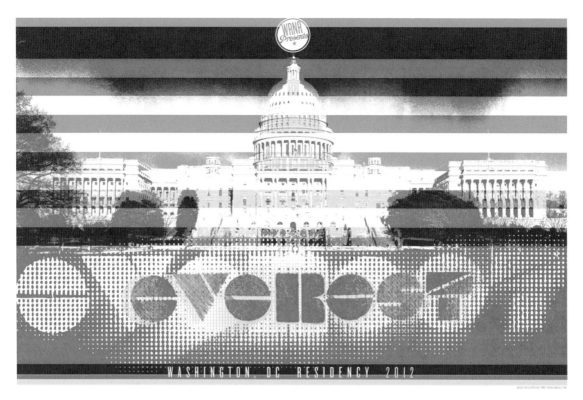

Everest, Washington DC Residency, three color screen print.

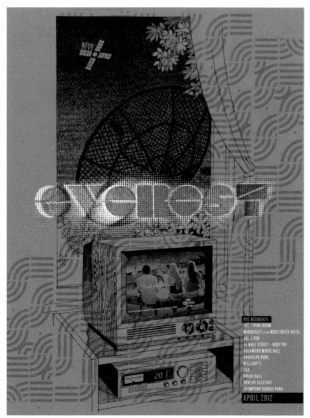

Everest, NYC Residency, three color screen print with silver metallic ink.

Everest, record release poster, 18" x 24" two color screen print.

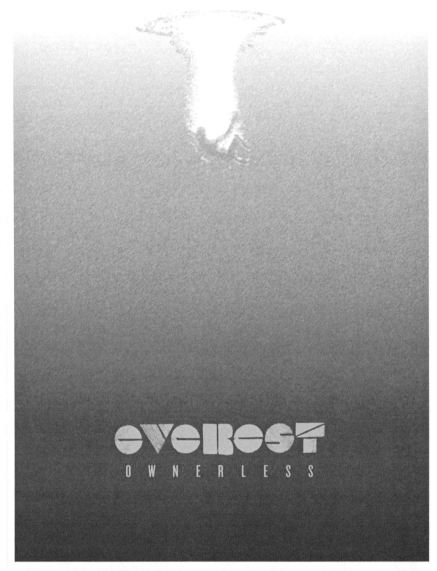

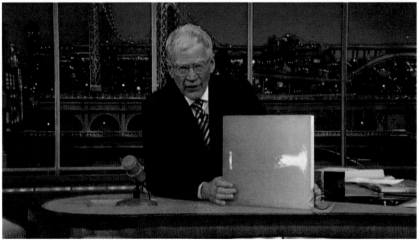

Everest Album promotional poster, David Letterman holding the album (sideways).

Everest, Chicago Residency, 18" x 24" three color screen print on cream stock. **Everest**, Chicago Residency, 18" x 24" three color screen print on specialty French paper stock.

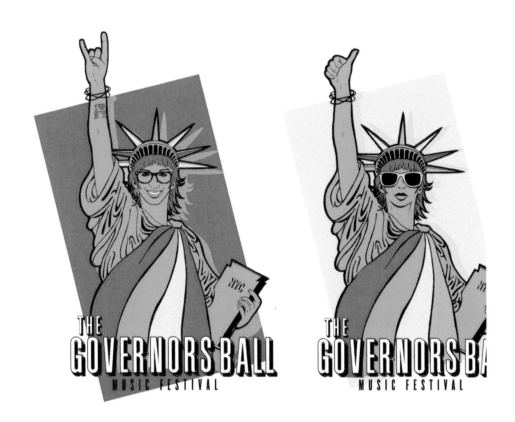

The Governors Ball, Festival promo, digital print on poster stock.

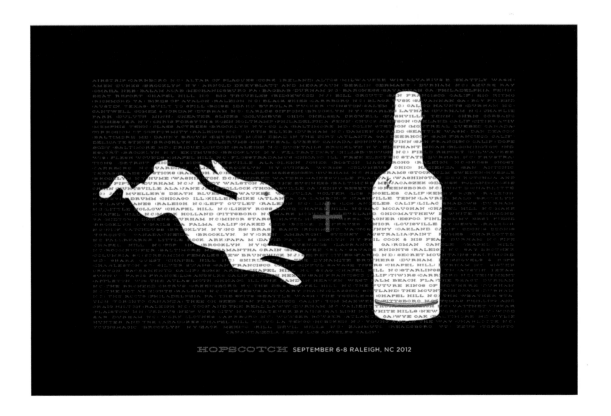

Hopscotch Music Festival, Festival promo, digital print on poster stock.

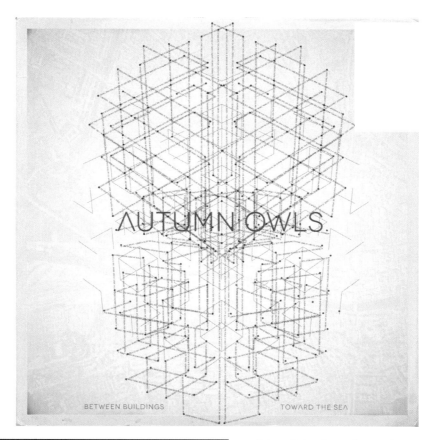

Autumn Owls, album release poster,
digital color on poster stock.

Tenacious D, promotional image, screen printed.

Kevin Bowe, Album release poster, digital color on poster stock.

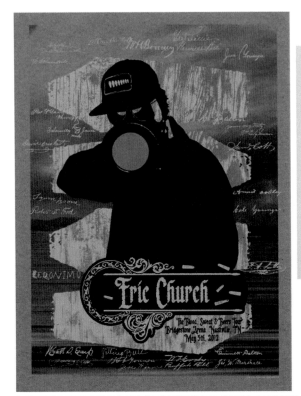
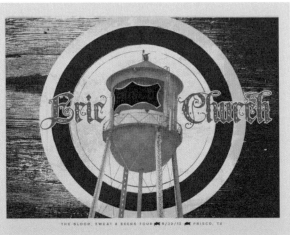
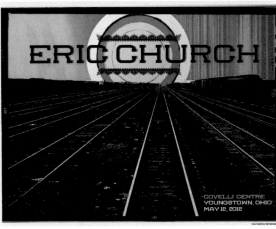
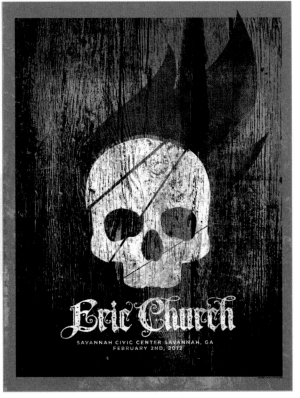

Eric Church, Bridgestone Arena, three color screen print with silver metallic on specialty French Paper.
Eric Church, Savannah Civic Center, three color screen print with silver metallic on specialty French Paper.
Eric Church, Frisco, two color screen print on specialty French Paper.
Eric Church, Covelli Centre, three color screen print on specialty French Paper.

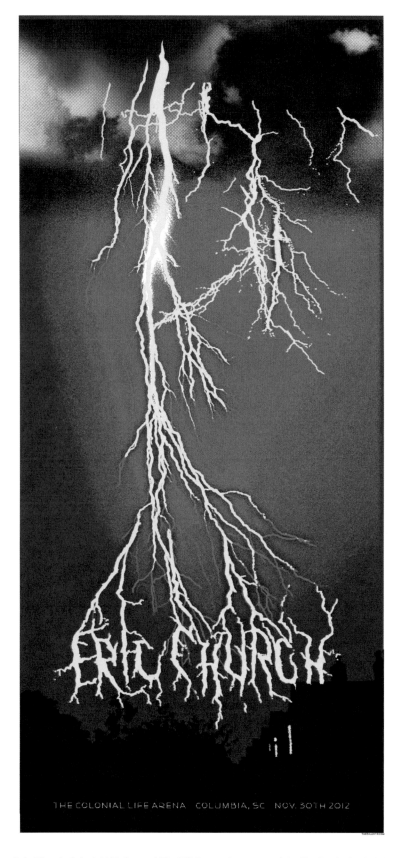

Eric Church, Colonial Life Arena, 12" x 26" three color screen print with glow in the dark ink.

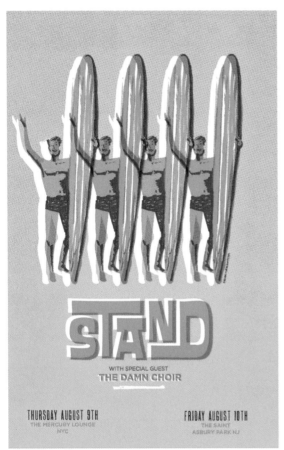

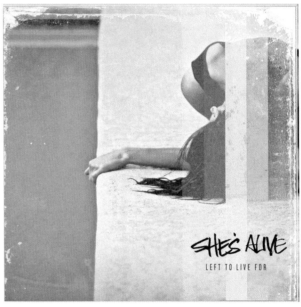

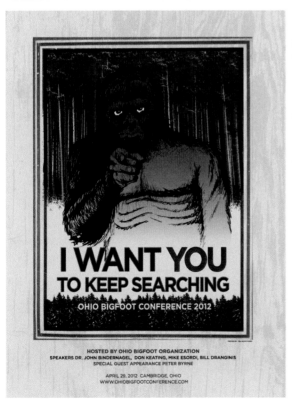

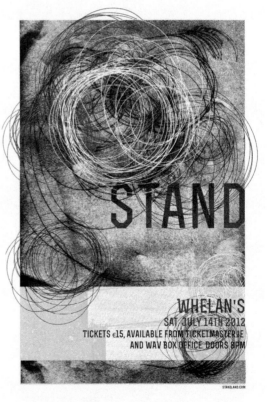

Top left, **Stand**, tour poster, digital color on poster stock. Top right, **She's Alive**, Album release poster, digital print on poster stock. Bottom left, **I Want You**, Big Foot Conference, digital print on poster stock. Bottom right, **Stand,** Whelan's, digital print on poster stock.

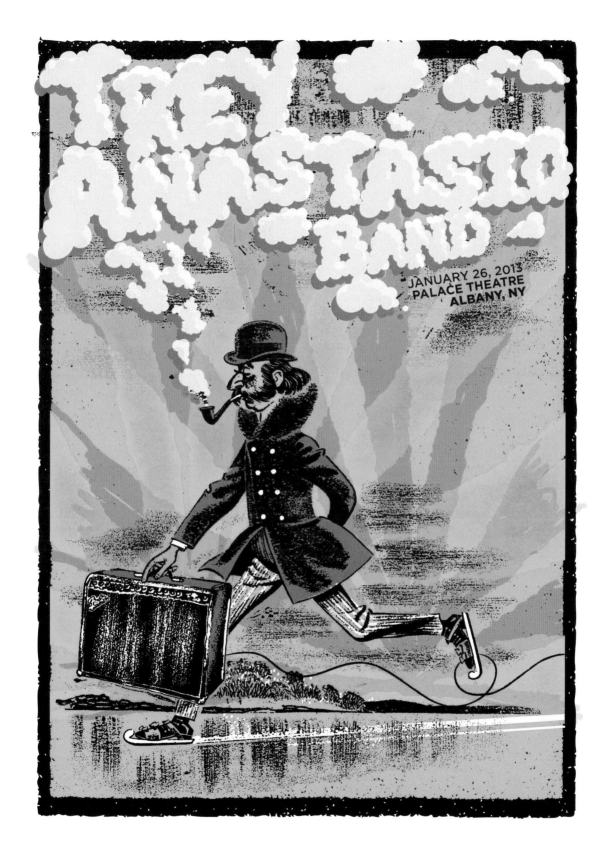

Trey Anastasio, Palace Theatre, 18" x 24" four color screen print with semi-opaque white ink.

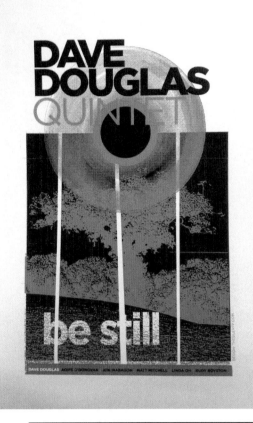

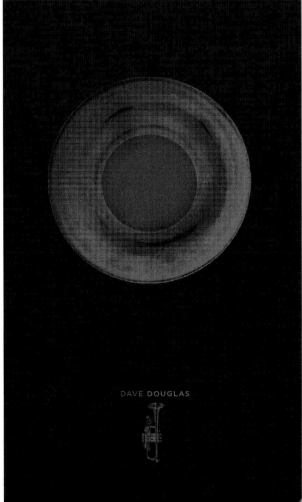

Top, **Dave Douglas**, album release poster, three color screen print.

Bottom, **Dave Douglas**, tour poster, digital print on poster stock.

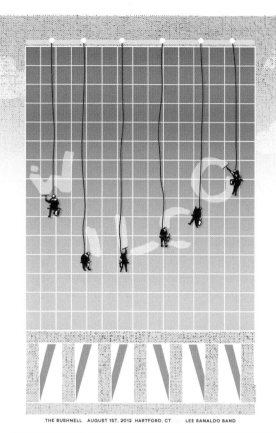

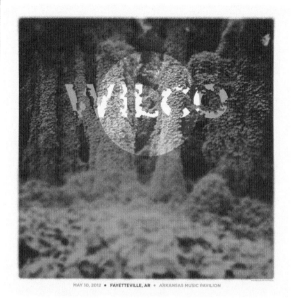

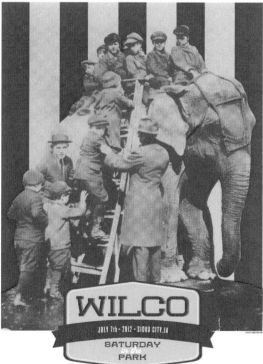

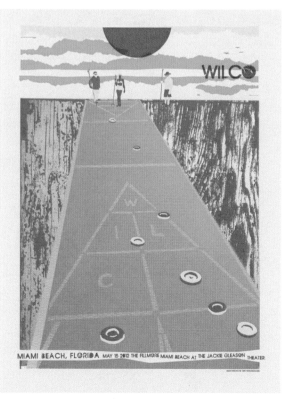

Top left, **Wilco**, The Bushnell, 18" x 24" four color screen print with semi-opaque white. Top right, **Wilco**, Arkansas Music Pavilion, 18" x 18" two color screen print on cream stock. Bottom left, **Wilco**, Saturday in the Park, 18" x 24" three color screen print. Bottom right, **Wilco**, The Fillmore, Miami, 18" x 24" four color screen print on specialty French Paper stock.

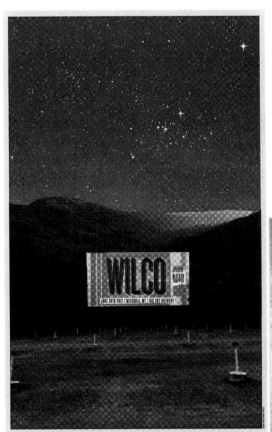

Wilco, Big Sky Brewery, 16" x 25" three color screen print with split fountain on French Paper.

Wilco, McCallum Theatre, 18" x 24" two color screen print.

Wilco, ASU Gammage, 16" x 25" two color screen print.

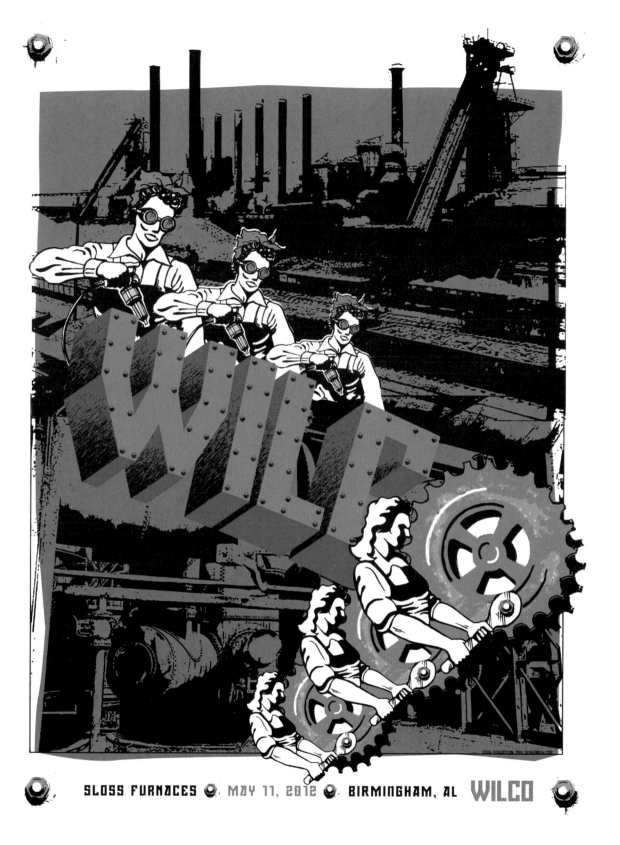

Wilco, Sloss Furnaces, 18" x 24" four color screen print with silver metallic ink.

CAPSULA SUBLIME

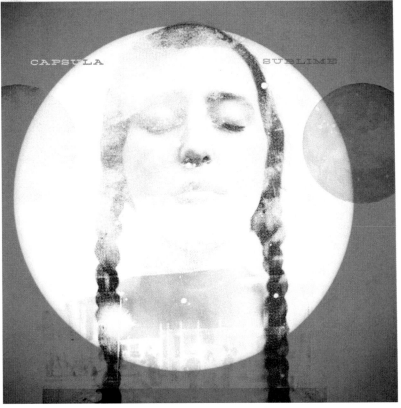

Capsula, album release posters, digital print on poster stock.

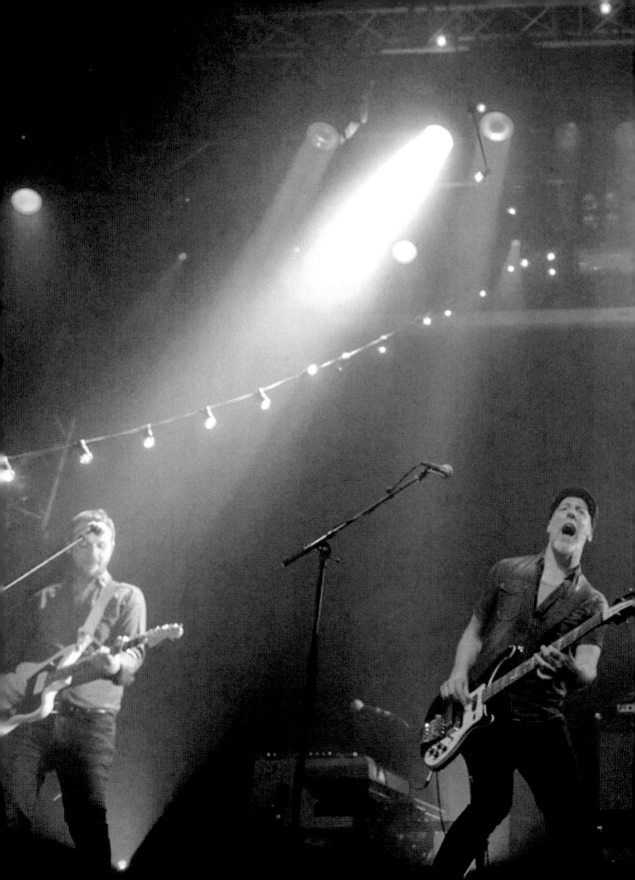

2013

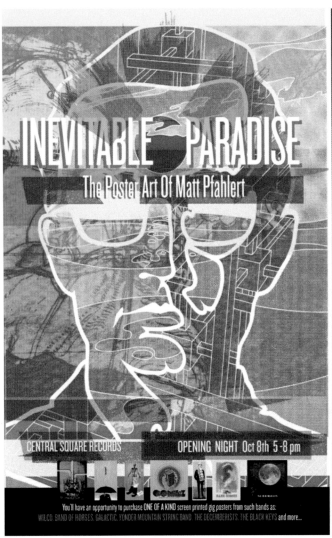

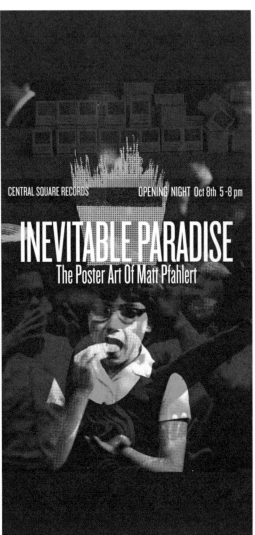

Promotional posters for art shows.

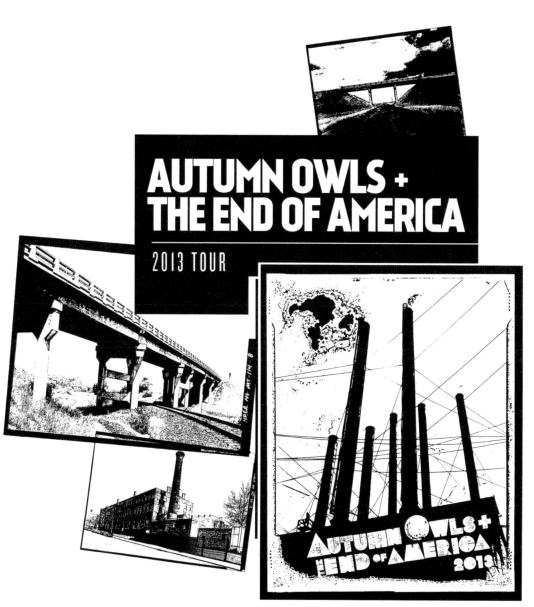

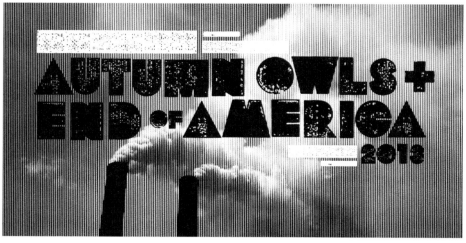

Autumn Owls, various tour promo materials.

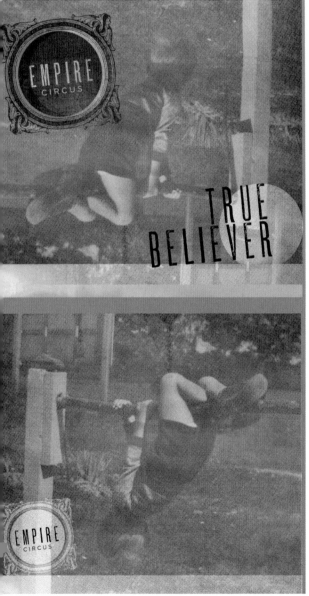

Empire Circus, 11" x 17" record release poster, digital print on poster stock.

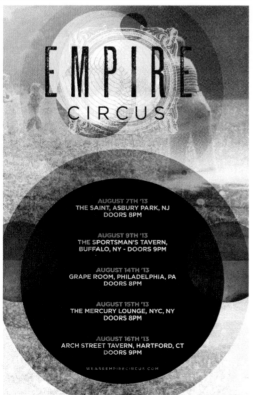

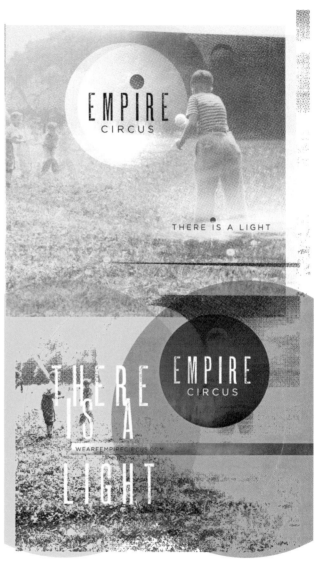

Empire Circus, 11" x 17" record release poster, digital print on poster stock.

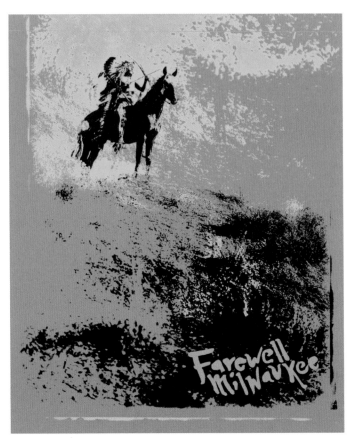

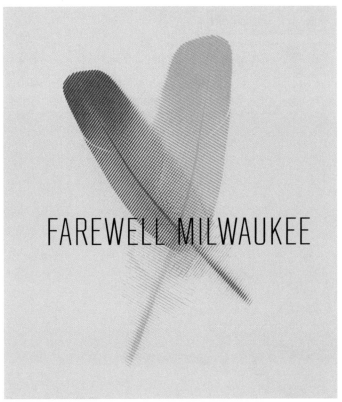

Farewell Milwaukee, 11" x 17" record release poster, digital print on poster stock.

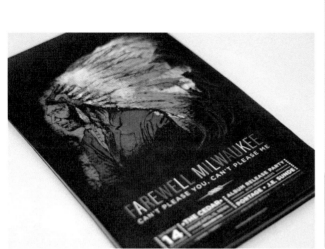

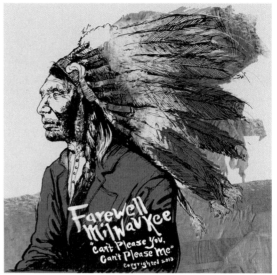

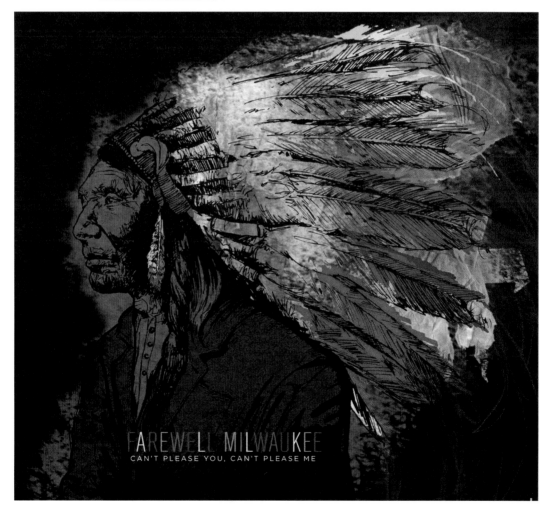

Farewell Milwaukee, 12" x 12" record release poster, digital print on poster stock.

Top left, **Farewell Milwaukee**, 12" x 12" record release poster, digital print on poster stock.
Top right, **Matrimony**, Chop Shop, 14" x 18" digital print on poster stock.
Bottom left, **Parachute Empire**, record release poster, 11" x 17" digital print on poster stock.
Bottom right, **Parachute Empire**, Chop Shop, 14" x 18" digital print on poster stock.

G.B. PARKER
MORE

G.B. PARKER MORE

1. TORTOISE SHELL BLUES
2. CAN'T GET ON BOARD
3. BUY A CONGRESSMAN
4. COME WHAT MAY
5. WE STAYED IN THE MOUNTAINS
6. FREEDOM TRAIN
7. FAMILY MAN
8. OH DE DO DE WA DAY
9. THESE HILLS
10. MORE

AVAILABLE AT GBPARKER.COM AND
OTHER FINE ONLINE RETAILERS.

G.B. PARKER
MORE

AVAILABLE AT GBPARKER.COM AND
OTHER FINE ONLINE RETAILERS.

G.B. PARKER MORE

1. TORTOISE SHELL BLUES
2. CAN'T GET ON BOARD
3. BUY A CONGRESSMAN
4. COME WHAT MAY
5. WE STAYED IN THE MOUNTAINS
6. FREEDOM TRAIN
7. FAMILY MAN
8. OH DE DO DE WA DAY
9. THESE HILLS
10. MORE

G.B. Parker, 11" x 17" record release poster, digital print on poster stock.

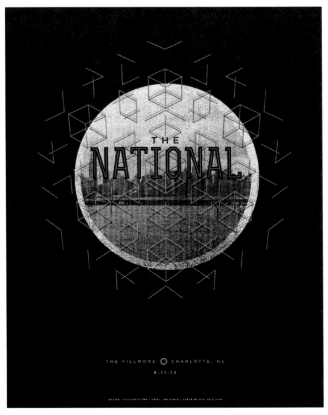

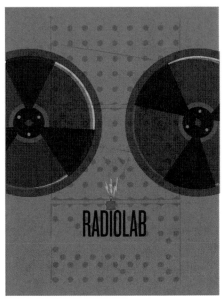

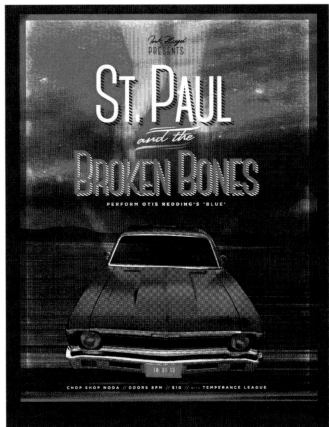

Top left, **St. Paul and the Broken Bones**, Chop Shop, 12" x 18" digital print on poster stock. Top right, **The National**, The Fillmore Charlotte, 16" x 20" two color screen print with glow-in-the-dark and silver metallic inks. **Radiolab**, promo poster, 11" x 17" digital color on poster stock.

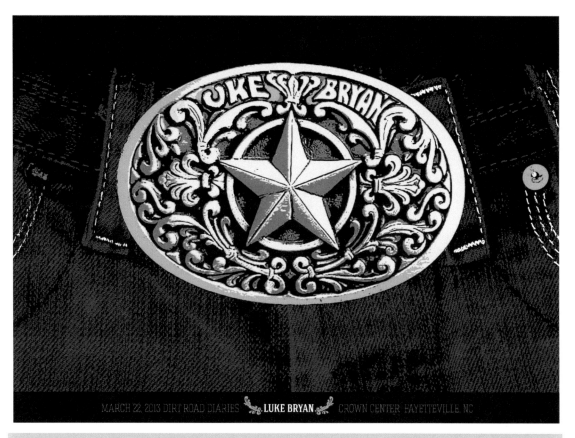

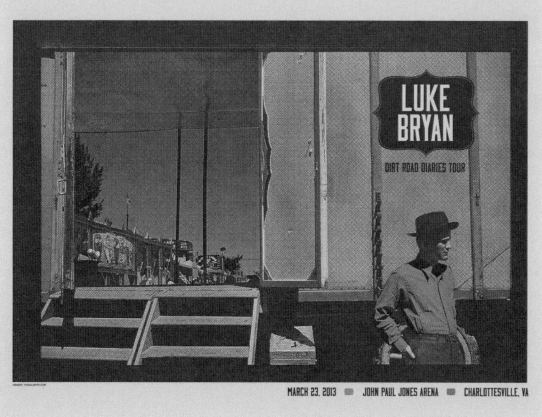

Luke Bryan, Crown Center, 24" x 18" four color screen print on French Paper paper.
Luke Bryan, John Paul Jones Arena, 24" x 18" three color screen print on French Paper paper.

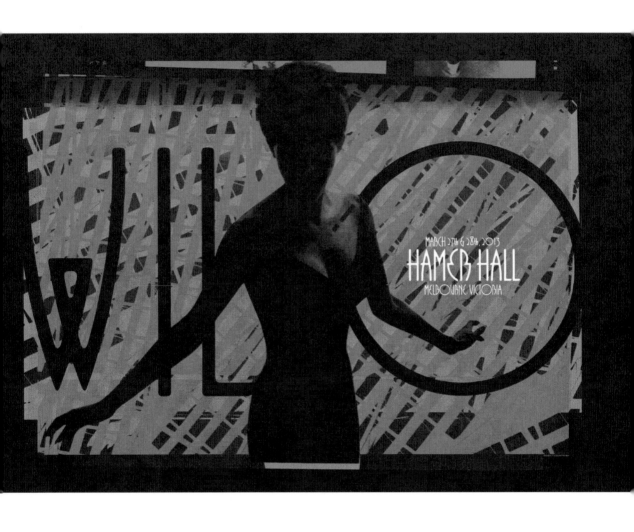

Wilco, Hammer Hall, 24" x 18", two color - one gold metallic on black poster stock.

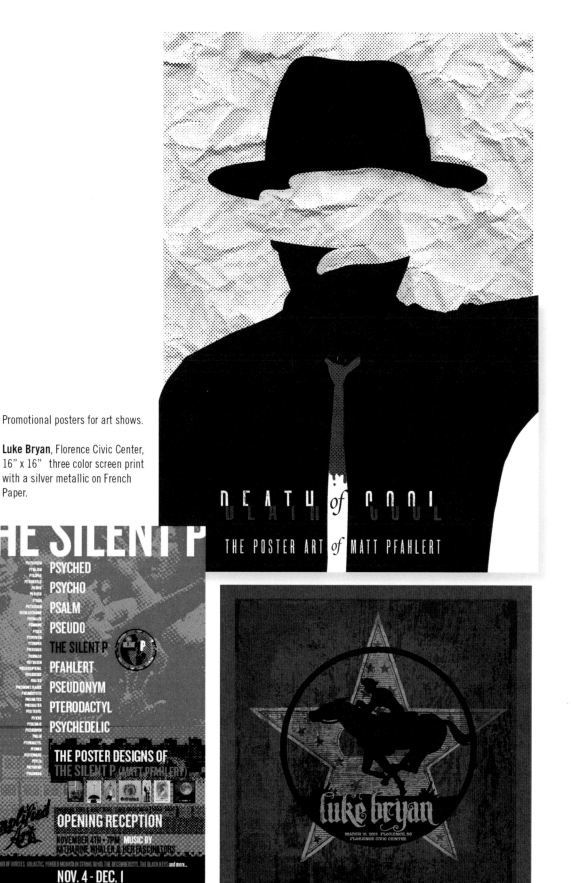

Promotional posters for art shows.

Luke Bryan, Florence Civic Center, 16" x 16" three color screen print with a silver metallic on French Paper.

DEATH *of* COOL
THE POSTER ART OF MATT PFAHLERT

THE SILENT P

PSYCHED
PSYCHO
PSALM
PSEUDO
THE SILENT P
PFAHLERT
PSEUDONYM
PTERODACTYL
PSYCHEDELIC

THE POSTER DESIGNS OF
THE SILENT P (MATT PFAHLERT)

OPENING RECEPTION
NOVEMBER 4TH • 7PM MUSIC BY
KATHARINE WHALEN & HER FASCINATORS

WILCO, BAND OF HORSES, GALACTIC, YONDER MOUNTAIN STRING BAND, THE DECEMBERISTS, THE BLACK KEYS and more...

NOV. 4 - DEC. 1
325 Blake Street (City Market) www.amplifiedgallery.com

luke bryan
MARCH 21, 2013 FLORENCE, SC
FLORENCE CIVIC CENTER

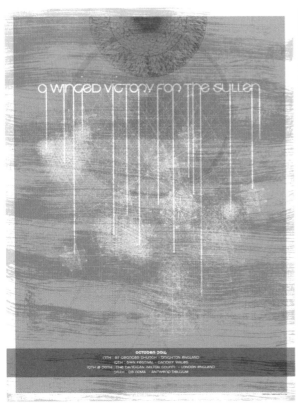

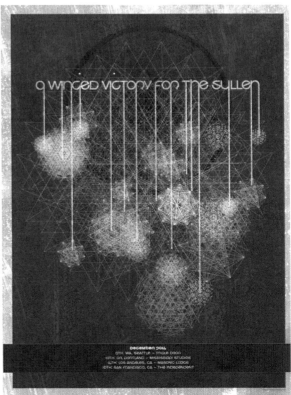

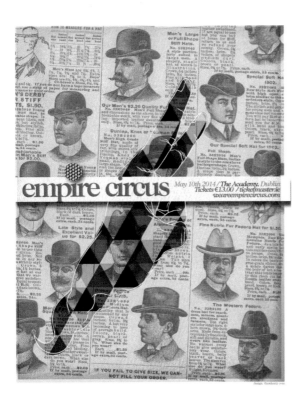

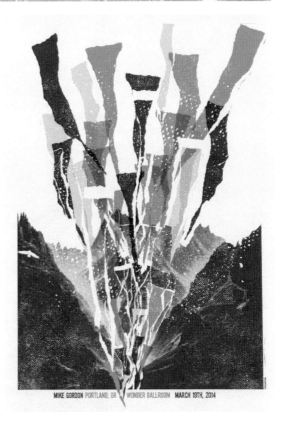

A Winged Victory for the Sullen, European tour poster, 18" x 24" three color screen print with silver metallic.
A Winged Victory for the Sullen, North America tour poster, 18" x 24" three color screen print with magenta metallic.
Empire Circus, The Academy, 13" x 19" digital print on poster stock.
Mike Gordon, Wonder Ballroom, 18" x 24" three color screen print on French Paper.

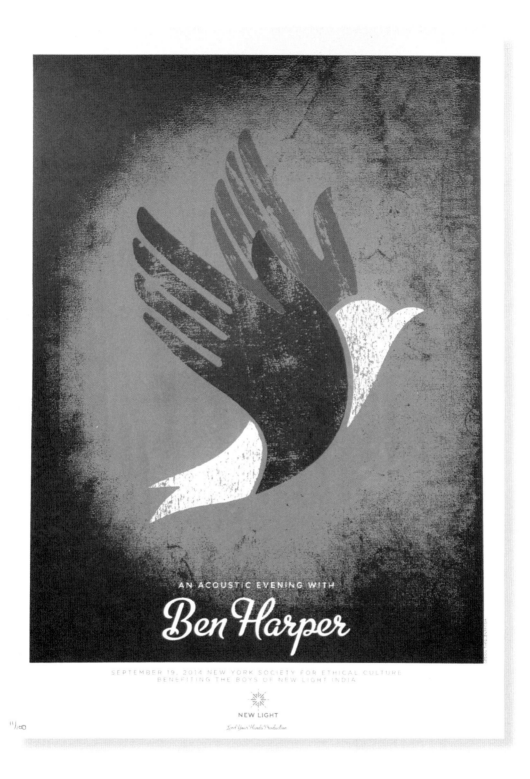

Ben Harper, NY Society for Ethical Culture, 18" x 24" three color screen print.

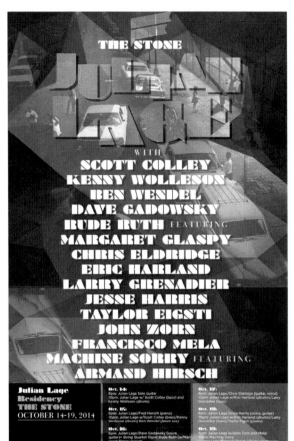
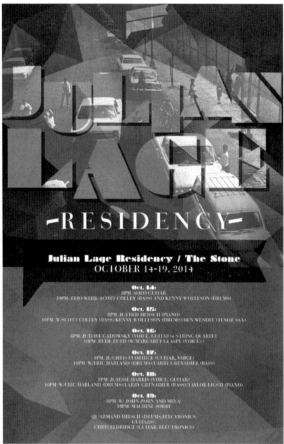
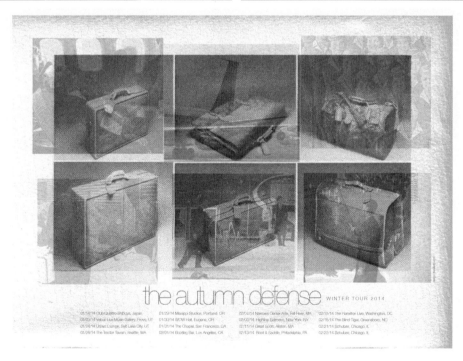

Julian Lage, tour poster, 11" x 17" digital print on poster stock.
The Autumn Defense, tour poster, 24" x 18" three color screen print on cream stock.

Trey Anastasio Band, Pabst Theater, three color screen print on French paper.

Sails Music Series, 11" x 17" digital print on poster stock.

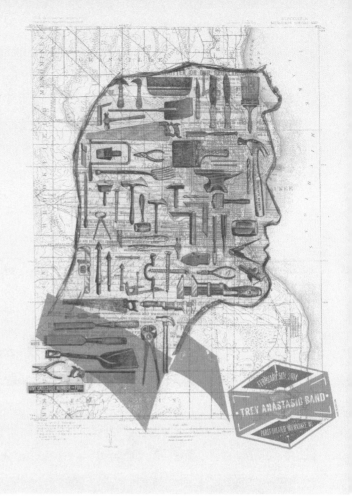

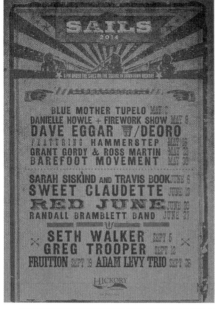

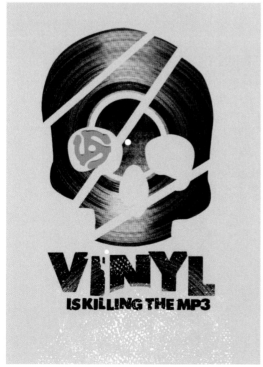

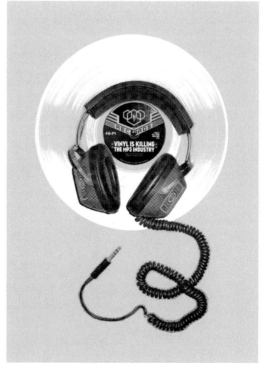

Vinyl is Killing the MP3, Art print, 12" x 16" screen print.

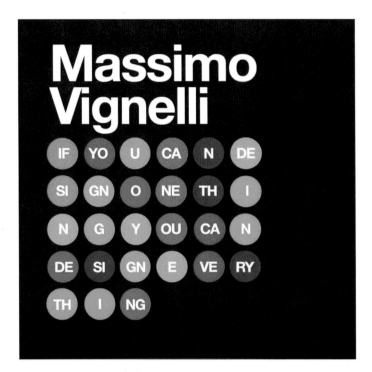

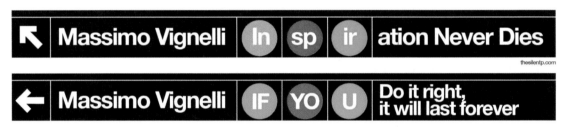

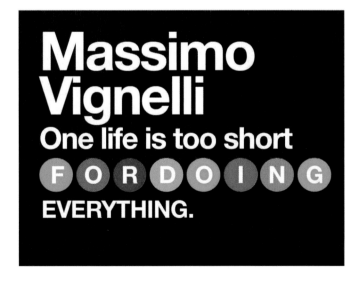

Massimo Vignelli, Art print, various sizes, gicleé print.

n e l s
c l i n e
&
j u l i a n
l a g e

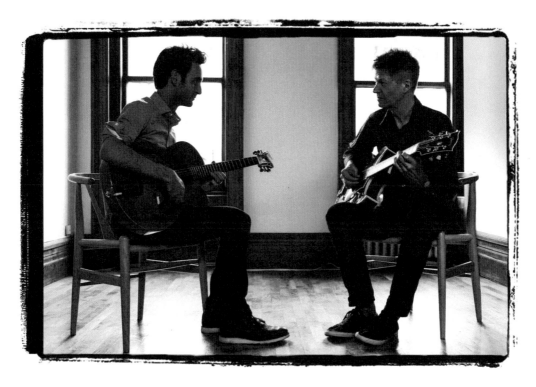

r o o m

Nels Cline & Julian Lage, record release poster, 11" x 17" digital print on poster stock.

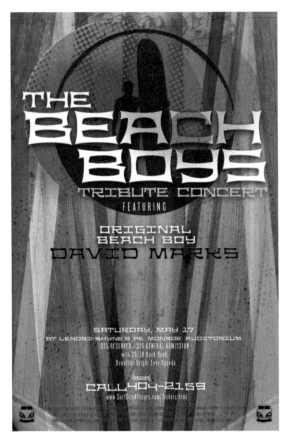

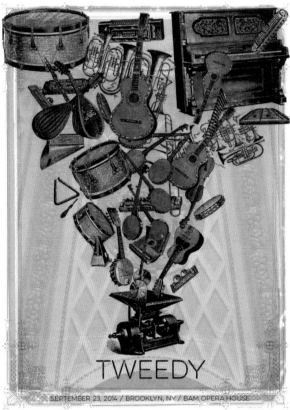

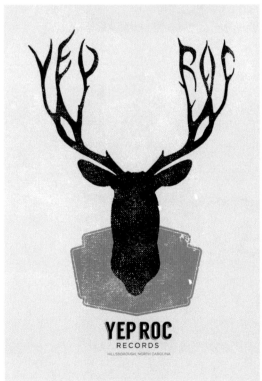

Beach Boys & Surf City All Stars, promo poster, 11" x 17" digital print on poster stock. **Tweedy**, BAM Opera House, 18" x 24" three color screen print.**Yep Roc**, promo poster, 11" x 17" two color screen print.

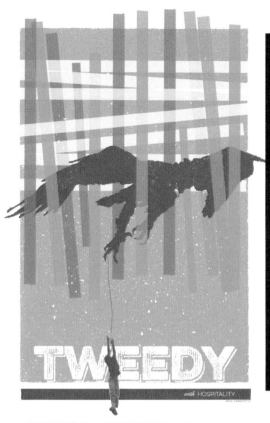

ATHENS, GEORGIA ■ SEPTEMBER 19, 2014 ■ GEORGIA THEATRE

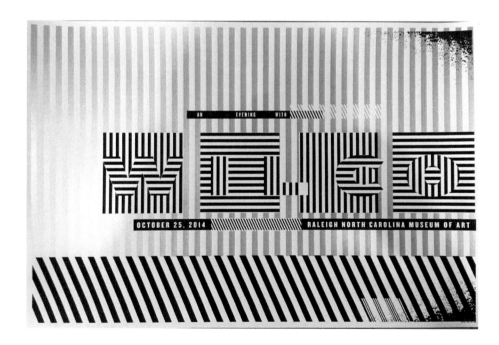

Tweedy, Georgia Theatre, 18" x 24" four color screen print.

Yep Roc, promo poster, 12" x 12" digital color on poster stock.

Wilco, Raleigh Museum of Art, 24" x 18" two color screen print with silver metallic.

125

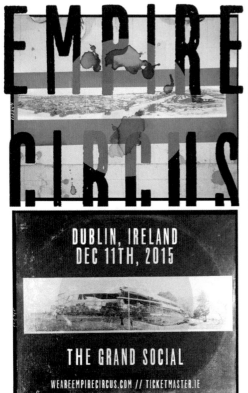

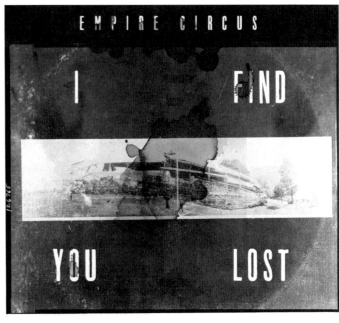

Empire Circus, 11" x 17" and 12" x 12" Single release poster, digital on poster stock.

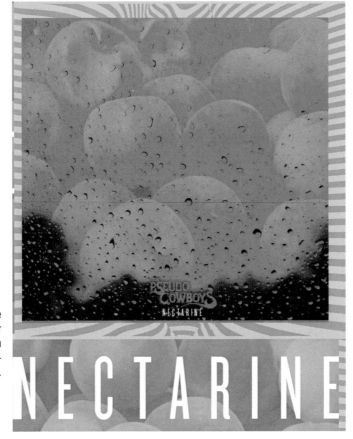

Pseudo Cowboys, album release poster, 11" x 17" digital on poster stock. Album art came with a scratch and sniff sticker (nectarine is a challenging scent to find by the way).

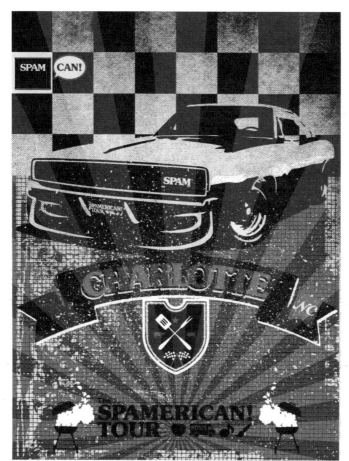

Spamerican! Tour, Charlotte, 18" x 24" three color with semi-opaque white.

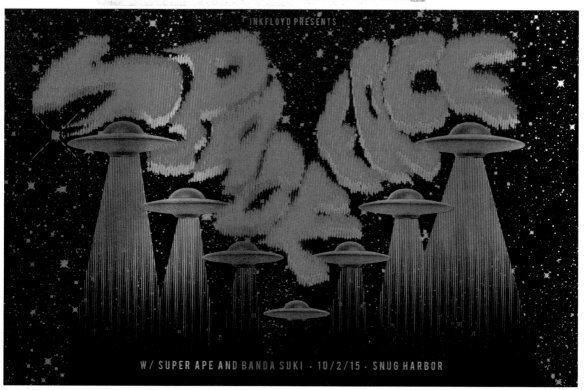

Spaceface, Snug Harbor, 12" 18" screen print on specialty rainbow foil poster stock.

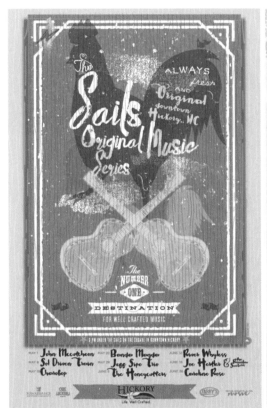
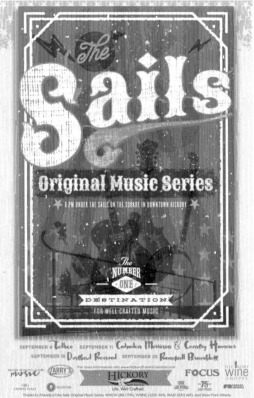
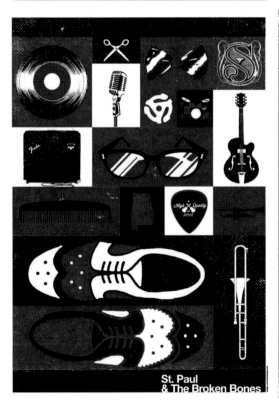
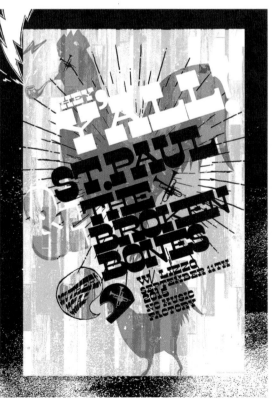

Top left and right, **Sails Music Series**, Downtown Hickory, 11" x 17" digital print on poster stock
St. Paul & The Broken Bones, Chop Shop, 12" x 18" digital on poster stock.
St. Paul & The Broken Bones, NC Music Factory, 18" x 24" three color screen print.

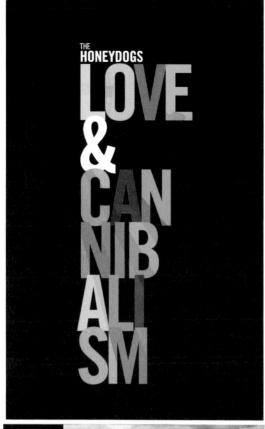

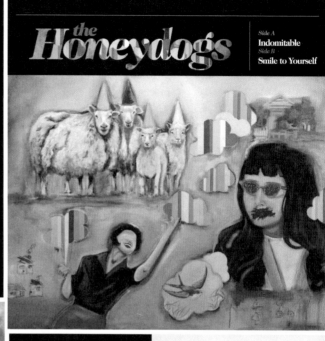

The Honeydogs, album release poster, 11" x 17" digital on poster stock.

The Low Counts, album release poster, 11" x 17" digital on poster stock.

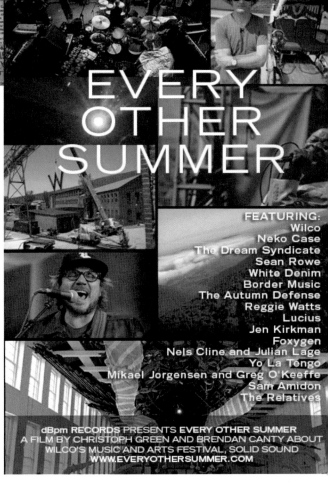

Every Other Summer, documentary promo, 11" x 17" digital print on poster stock.

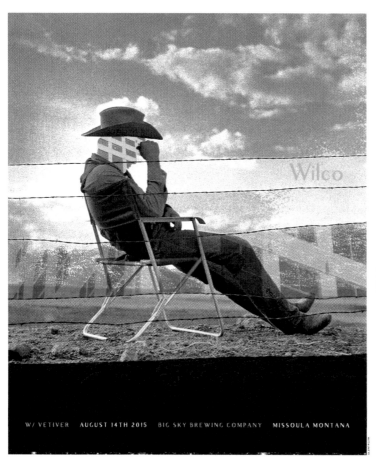

Wilco, Big Sky Brewing, 18" x 24" three color screen print.

Wilco, State Theatre, 18" x 24" three color screen print with silver metallic ink.

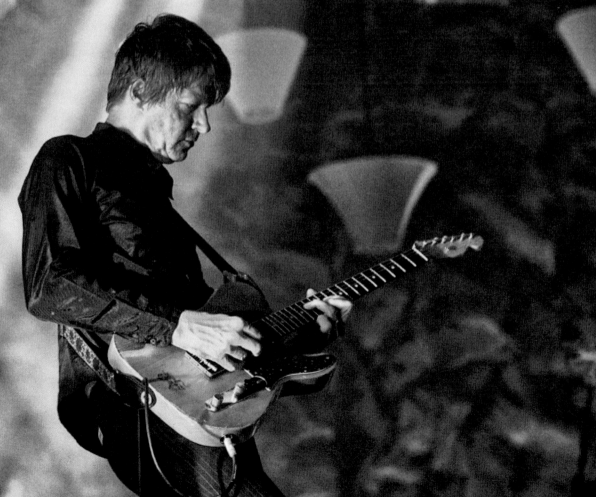

2016

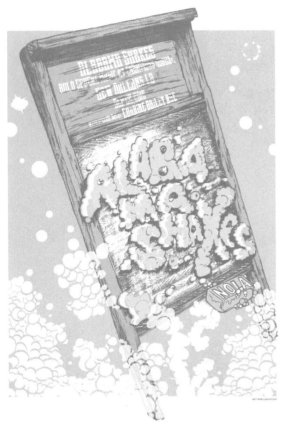

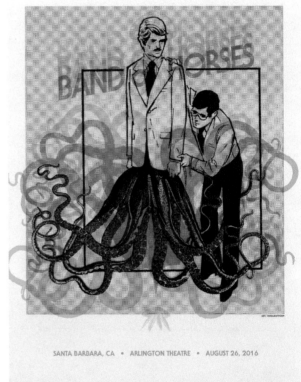

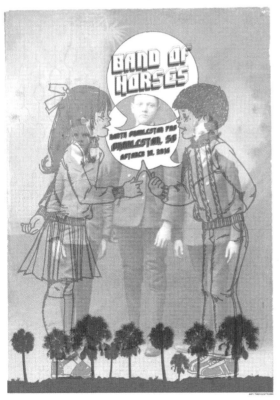

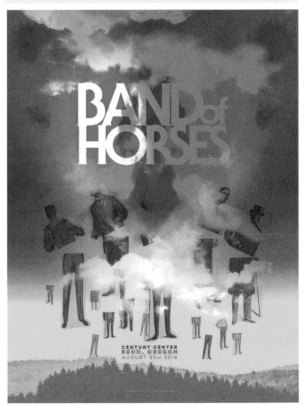

Alabama Shakes, NOLA, 18" x 24" three color screen printed on silver metallic paper with a semi-opaque white.
Band of Horses, Paramount Theatre, 18" x 24" three color screen print on French Paper stock.
Band of Horses, Arlington Theatre, 18" x 24" three color screen print on French Paper stock.
Band of Horses, N. Charleston PAC, 18" x 24" three color screen print.

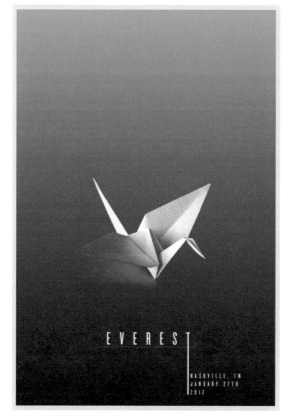

Band of Horses, Paramount Theatre, 24" x 18" four color process screen print on specialty French Paper stock.

Everest, 11" x 17" digital on poster stock.

Footcandle Film Festival, festival poster,
11" x 17" digital on poster stock.

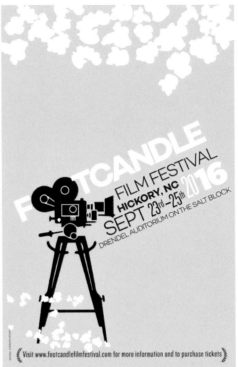

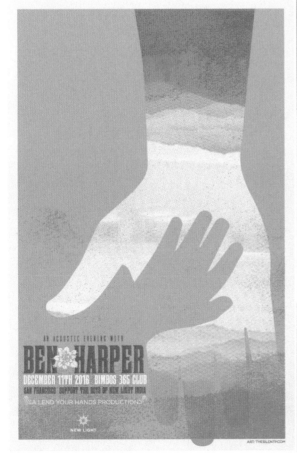

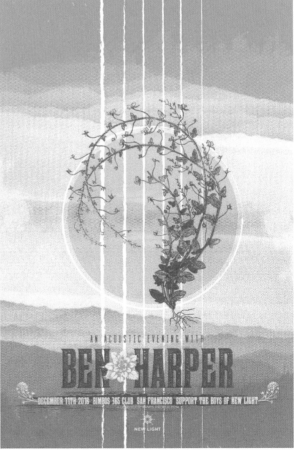

Ben Harper,Bimbos, 11" x 17" digital print on poster stock.

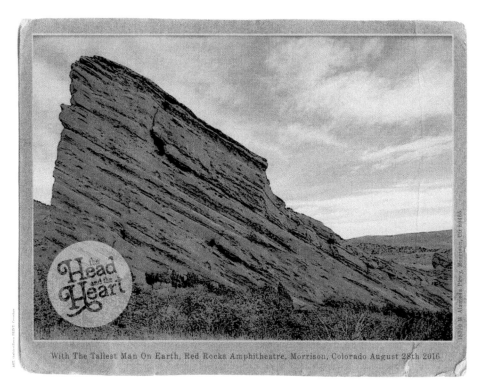

The Head and the Heart, Red Rocks Amphitheater, 24" x 18" four color process screen print.

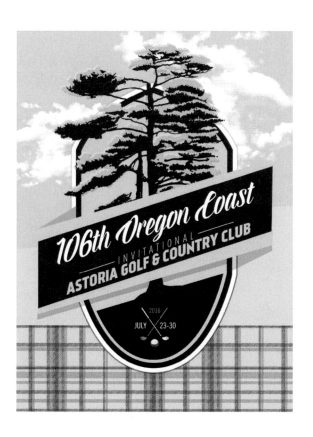

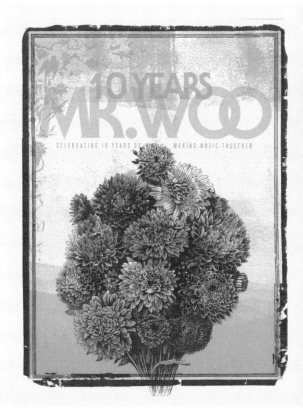

106th Oregon Coast, event poster, 18" x 24" four color screen print on cream stock.
Mr. Woo, anniversary show poster, 18" x 24" three color screen print on cream stock with overprints.

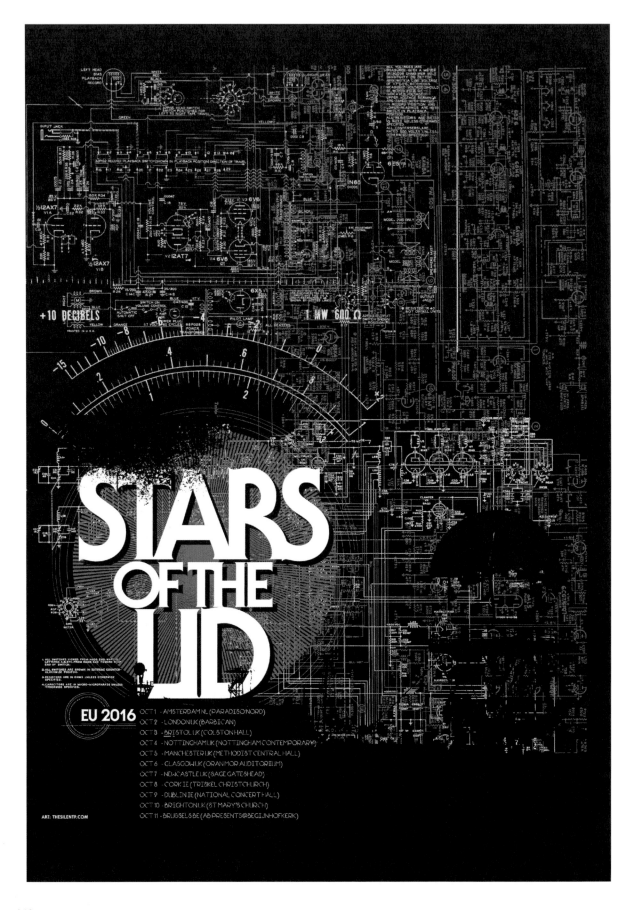

STARS OF THE LID

EU 2016

OCT 1 - AMSTERDAM NL (PARADISO NORD)
OCT 2 - LONDON UK (BARBICAN)
OCT 3 - BRISTOL UK (COLSTON HALL)
OCT 4 - NOTTINGHAM UK (NOTTINGHAM CONTEMPORARY)
OCT 5 - MANCHESTER UK (METHODIST CENTRAL HALL)
OCT 6 - GLASGOW UK (ORAN MOR AUDITORIUM)
OCT 7 - NEWCASTLE UK (SAGE GATESHEAD)
OCT 8 - CORK IE (TRISKEL CHRISTCHURCH)
OCT 9 - DUBLIN IE (NATIONAL CONCERT HALL)
OCT 10 - BRIGHTON UK (ST MARY'S CHURCH)
OCT 11 - BRUSSELS BE (AB PRESENTS @ BEGIJNHOFKERK)

ART: THESILENTP.COM

WILCO

BOISE, IDAHO
AT THE MORRISON CENTER
AUGUST 31, 2016
W/ JOAN SHELLEY

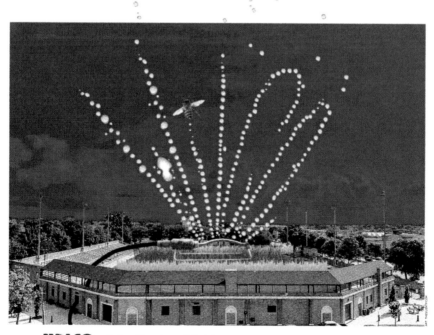

WILCO · Madison, WI. · August 19th, 2016 · Breese Stevens Field · w/ Kurt Vile & The Violators

Wilco, The Morrison Center, 24" x 18" two color screen print on cream with overprinting. **Wilco**, Breese Stevens Field, 24" x 18" four color process screen print. Opposite page, **Stars of the Lid**, European tour poster, 18" x 24" three color screen print on black stock.

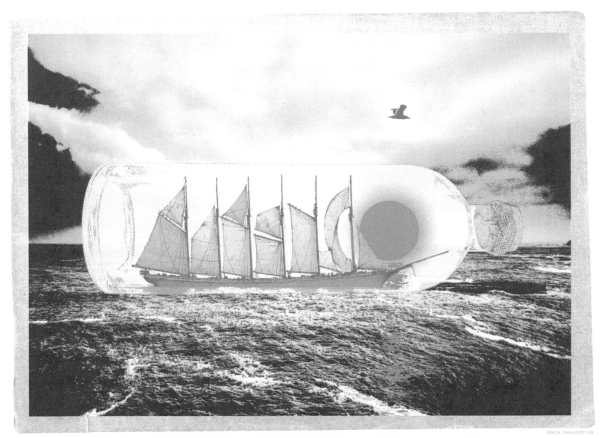

WILCO · FEBRUARY 9TH 2016 · NORFOLK, VIRGINIA · THE NORVA · *with* GIRLPOOL

Wilco, The Norva, 24" x 18" four color screen print on natural white stock.

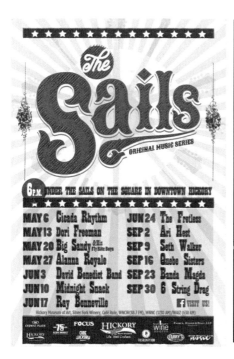

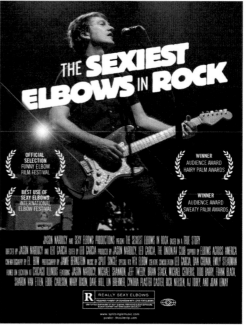

Tony Eltora, promo poster, 11" x 17" digital on poster stock. **Sails Music Series**, downtown Hickory, 11" x 17" digital on poster stock **The Sexiest Elbows in Rock**, promo poster, 11" x 17" digital on poster stock..

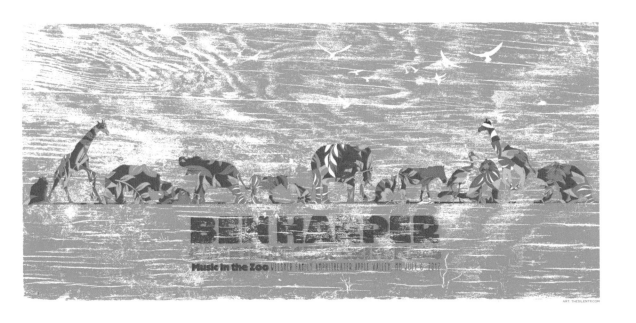

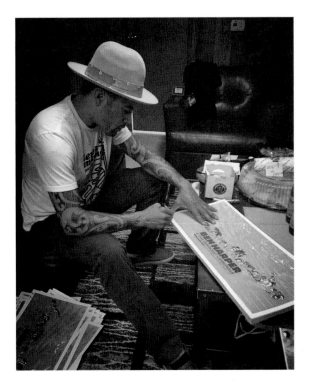

Ben Harper & The Innocent Criminals, Music in the Zoo, four color
screen print. Ben Harper signing the poster backstage at the event.

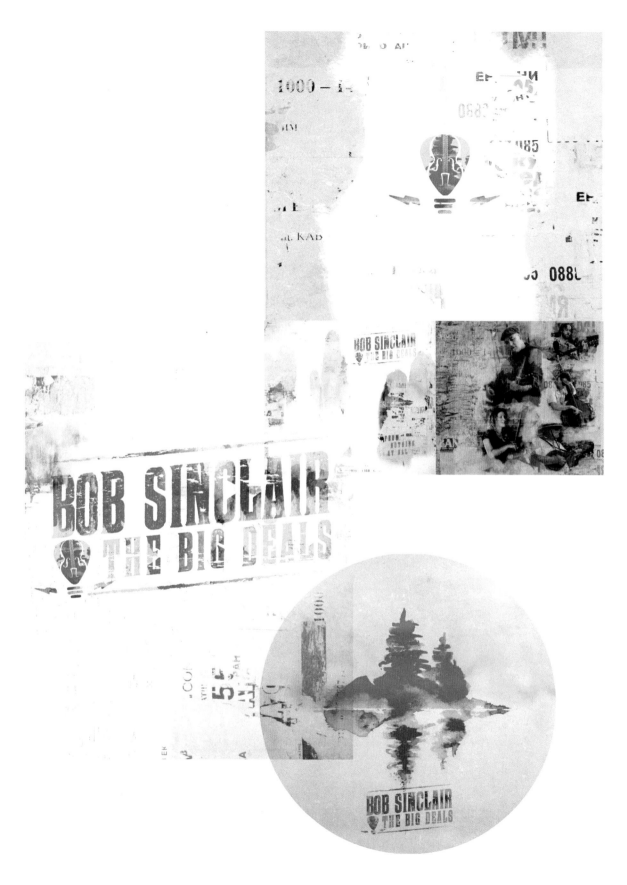

Bob Sinclair & The Big Deals, album release poster, 11" x 17" digital on poster stock.

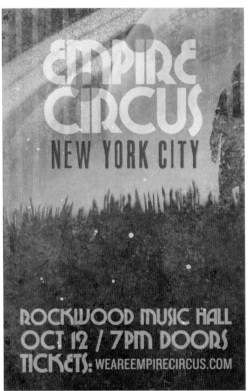

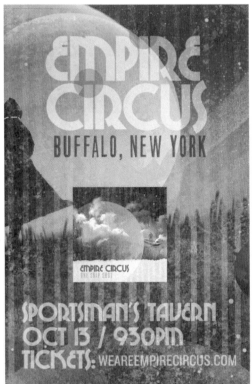

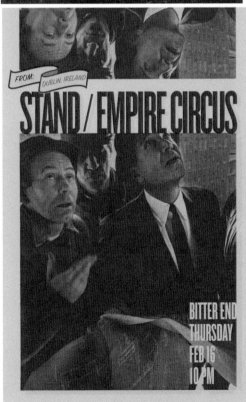

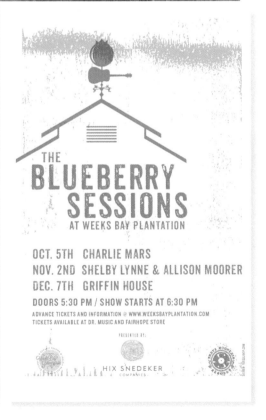

Top left and right, **Empire Circus**, Rockwood Music Hall, 11" x 17" digital on poster stock.
Stand, Bitter End, 11" x 17" digital on poster stock.
The Blueberry Sessions, Weeks Bay Plantation, 11" x 17" digital on poster stock.

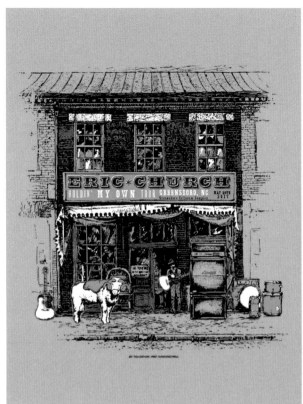

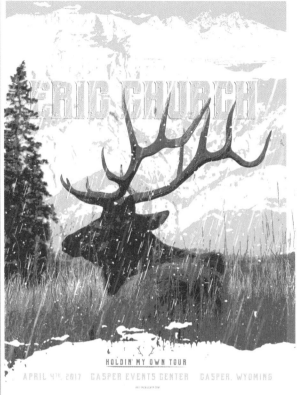

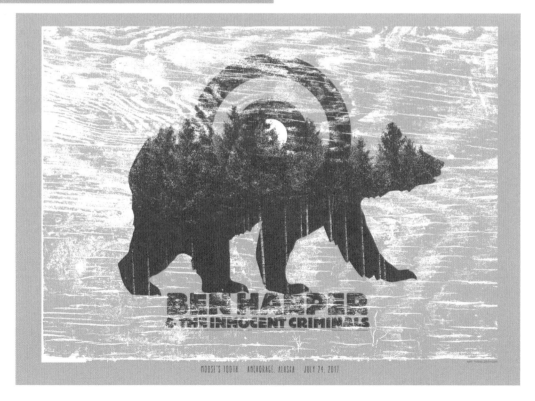

Eric Church, Greensboro Coliseum, 18" x 24" four color screen print on specialty French paper stock.
Eric Church, Gasper Events Center, 18" x 24" 3 color with a semi-transparent pearl white for rain drops, on white stock.
Ben Harper & The Innocent Criminals, Music in the Zoo, four color screen print.

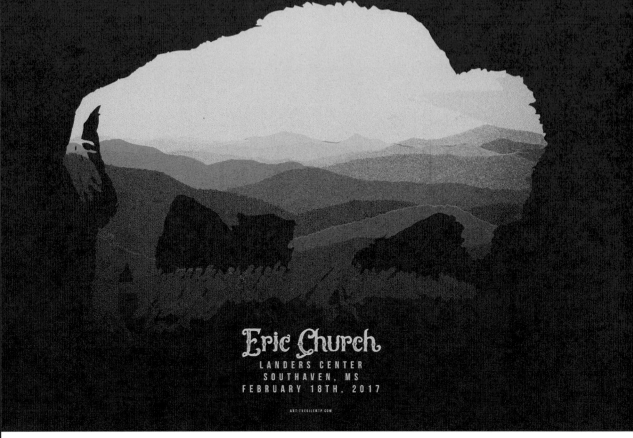

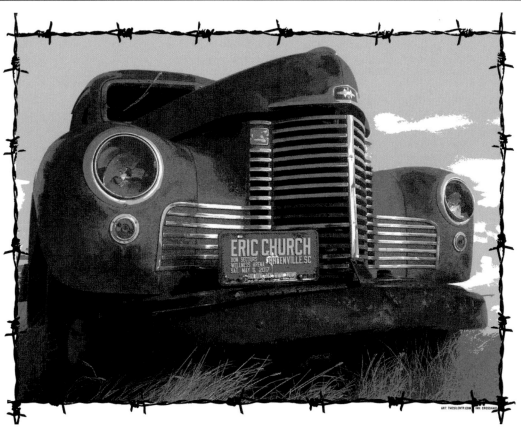

Eric Church, Landers Center, 24" x 18" three color screen print on black stock.
Eric Church, Wellness Arena, 24" x 18" four color screen print.

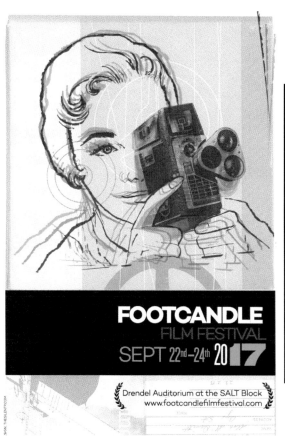

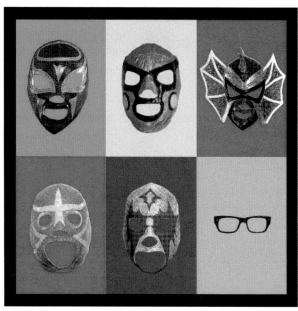

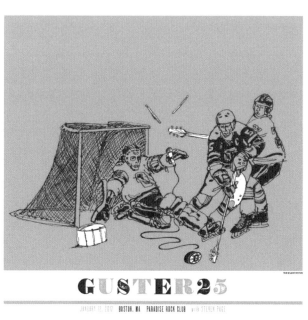

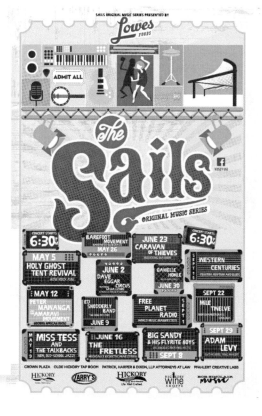

Top left, **Footcandle Film Festival**, Drendel Auditorium, 11" x 17" digital on poster stock. Top right, **Los Straitjackets & Nick Lowe**, promo poster, 12" x 12" five color screen print. **Guster**, Paradise Rock Club, 18" x 18" two color screen print with silver metallic ink. **The Sails Music Series**, Downtown Hickory, 11" x 17" digital on poster stock.

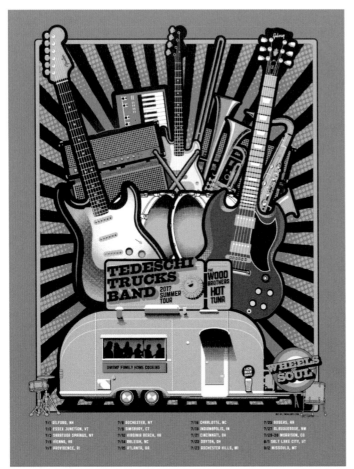

Tedeschi Trucks band, tour poster, 18" x 24" five color screen print with silver metallic ink.

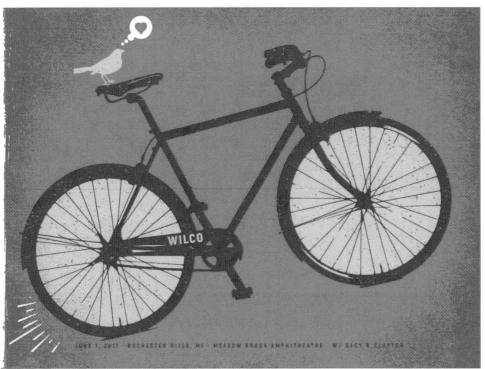

Wilco, Meadow Brook Amphitheatre, 24" x 18" three color screen print on specialty French Paper stock.

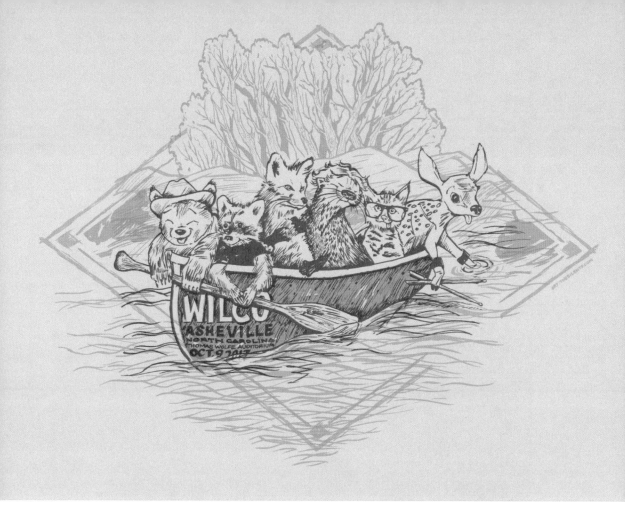

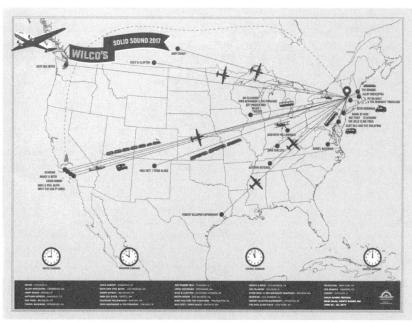

Wilco, Thomas Wolfe Auditorium, 24" x 18" three color screen print on specialty French Paper stock.
'WILCANOE' was chosen as one of 265 Regional Winners in PRINT Magazine's Regional Design Awards in the Poster category.
Solid Sound Festival, Mass MoCA, 24" x 18" three color screen print on specialty French Paper stock.

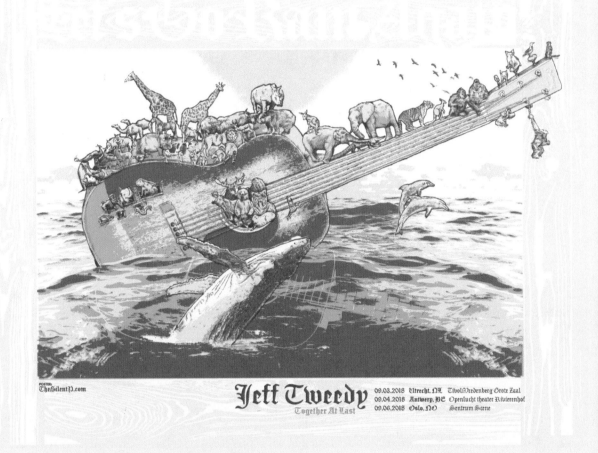

Jeff Tweedy, EU tour poster, 24" x 18" two color screen print on specialty French Paper stock.

Israel Nash, tour poster, 12" x 18" digital on poster print.

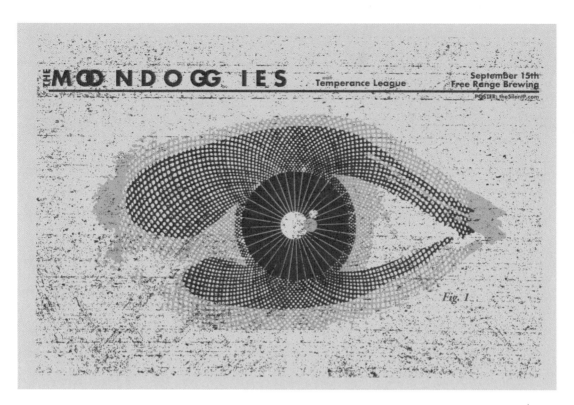

The Moondoggies, Free Range Brewing, one color screen print on specialty French Paper stock.
The Moondoggies, general tour poster, two color screen print.

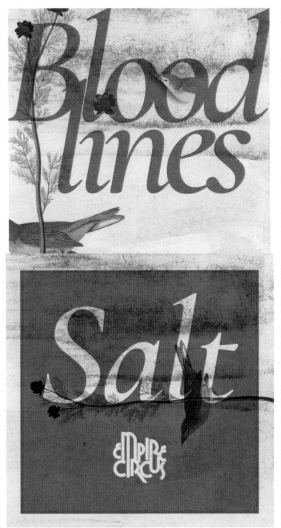

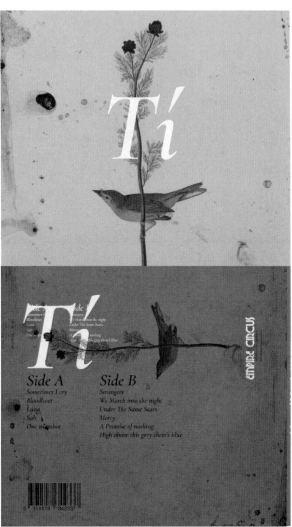

Empire Circus, album release poster, 11" x 17" digital on poster stock.

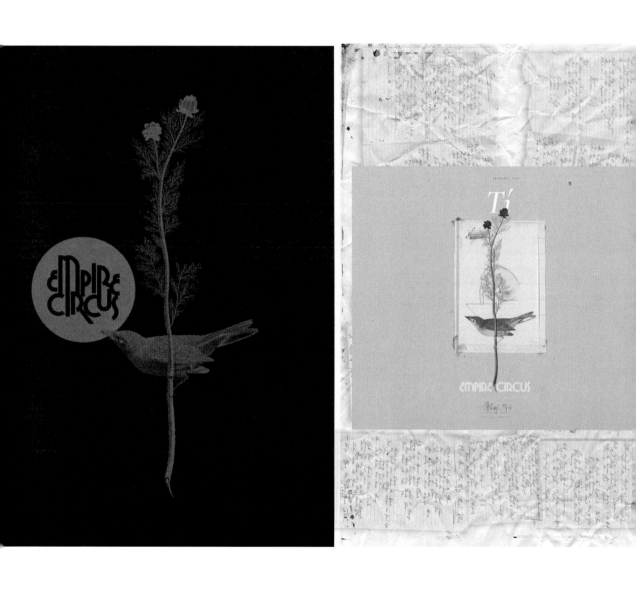

Empire Circus, album release poster, 11" x 17" digital on poster stock.

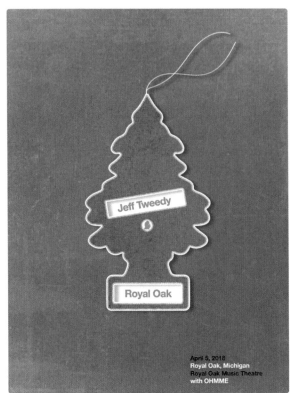

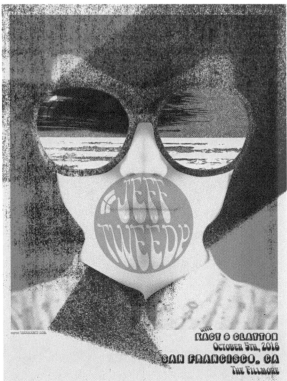

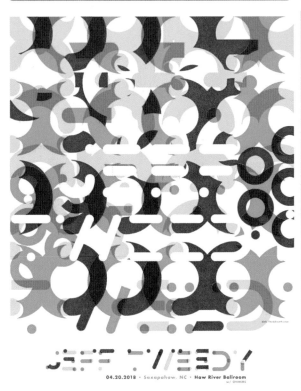

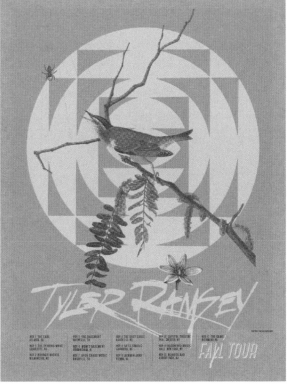

Top left: **Jeff Tweedy**, Royal Oak Music Theatre, three color screen print. Top right: **Jeff Tweedy**, The Fillmore, two color screen print on specialty French Paper stock with overprints. Bottom left: **Jeff Tweedy**, Haw River Ballroom, three color screen print with overprinting. Bottom right: **Tyler Ramsey**, tour poster, 18" x 24" two color screen print on specialty French Paper stock.

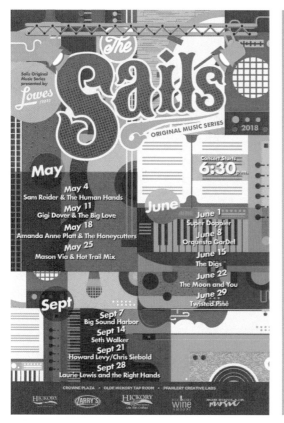

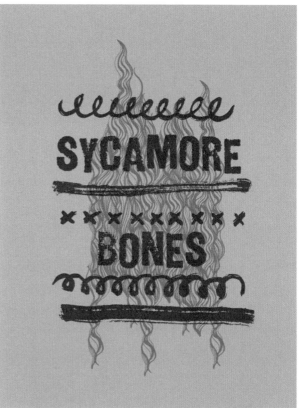

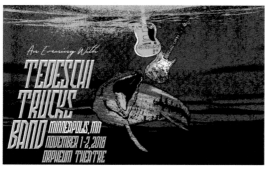

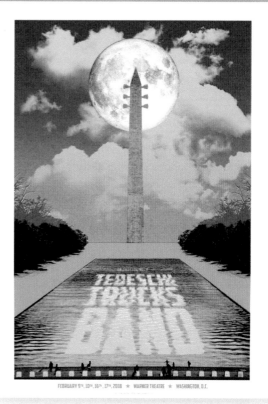

Top left: **The Sails Music Series**, Downtown Hickory, digital print on poster stock. Top right: **Sycamore Bones**, promo poster, 11" x 17" digital print on poster stock. Bottom left: **Tedeschi Trucks band**, Orpheum Theatre, 18" x 24" three color screen print with a split fountain. Bottom right: **Tedeschi Trucks band**, Warner Theatre, 18" x 24" four color screen print with a split fountain and glow-in-the-dark ink.

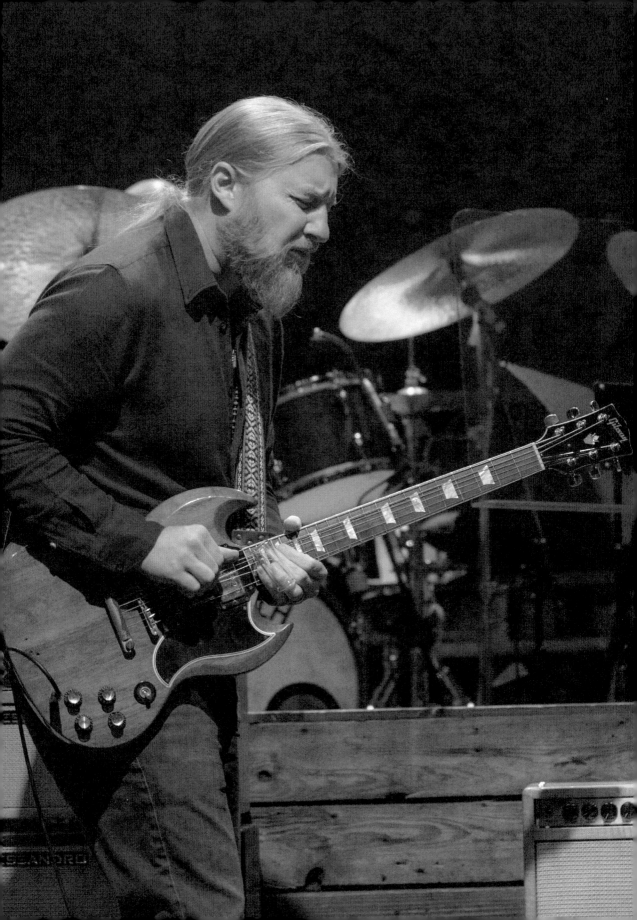

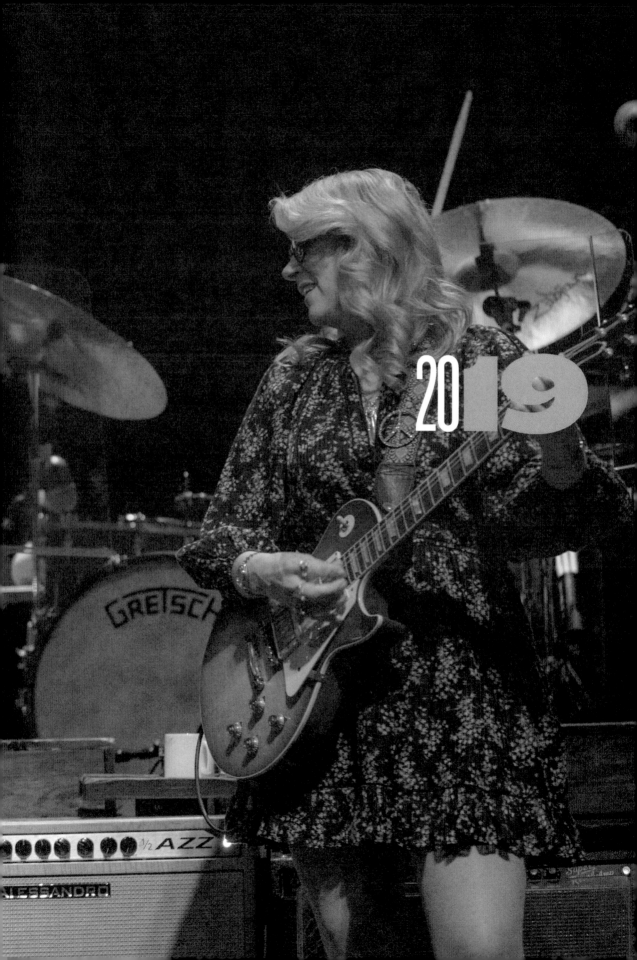

Matt Curran, promo poster, 11" x 17" digital on poster stock.

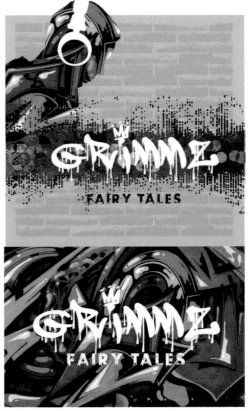

Grimmz, theatre poster, 11" x 17" digital on poster stock.

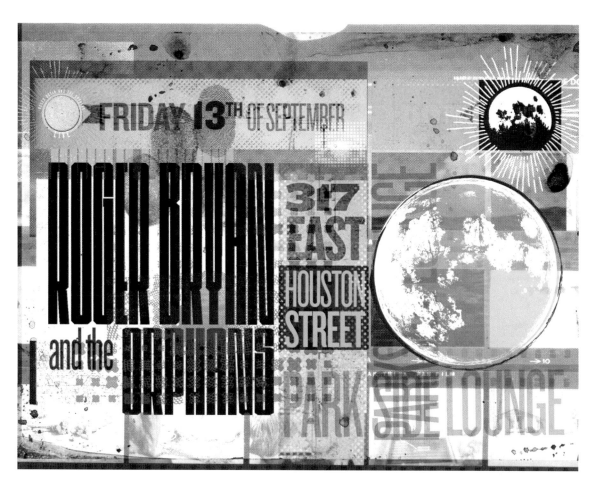

Roger Bryan and the Orphans, Park Side Lounge,
17" x 11" digital on poster stock.

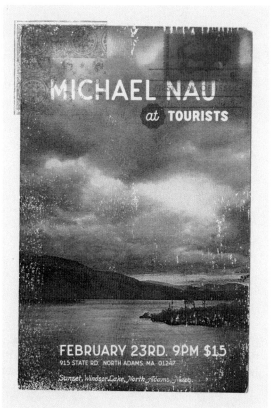

Michael Nau, Tourists, 11" x 17" digital on poster stock.

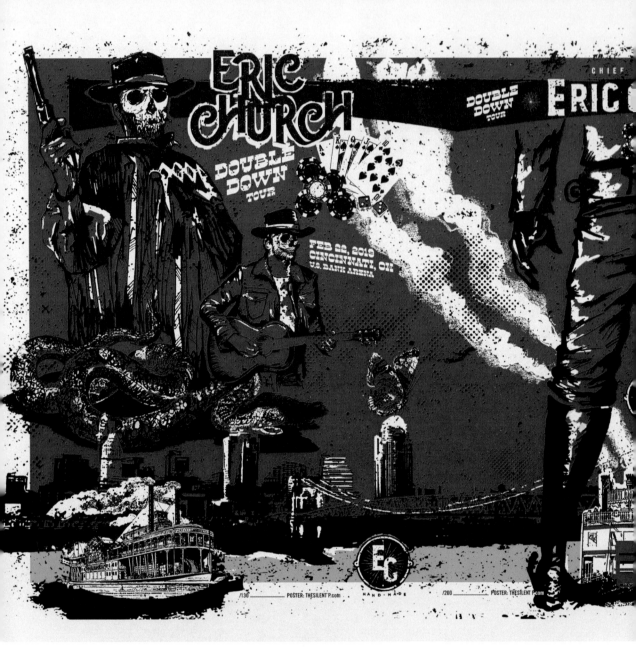

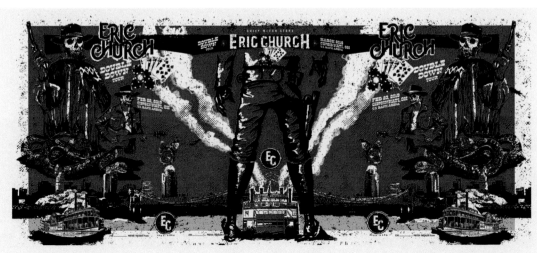

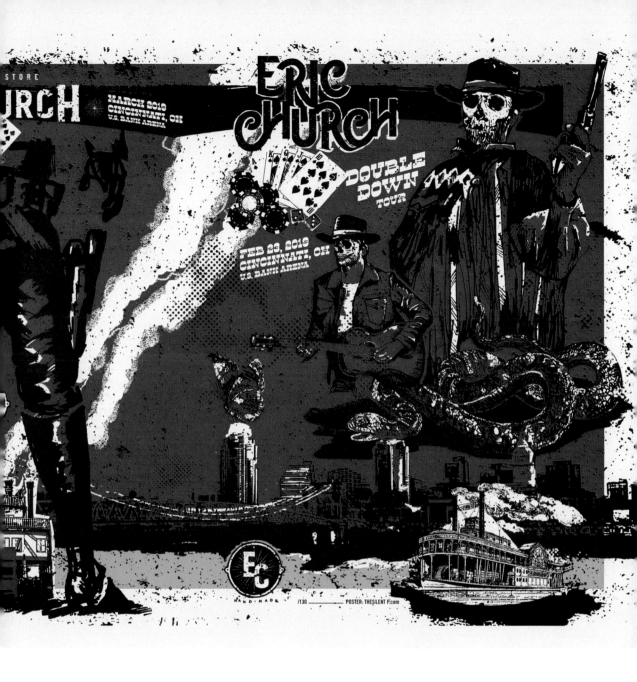

Eric Church, U.S. Bank Arena, triptych poster set, each poster 18" x 24", three color screen print.

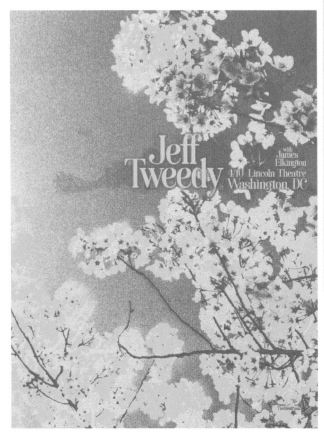

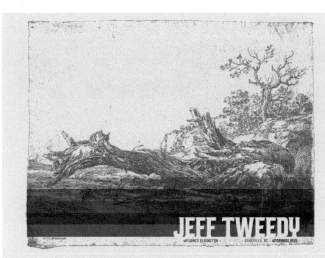

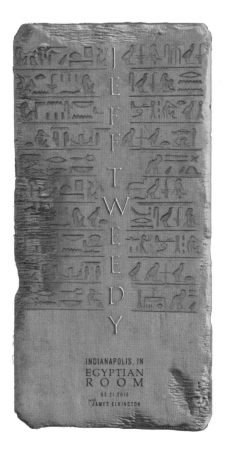

Top left: **Jeff Tweedy**, Lincoln Theatre, two color screen print on specialty French Paper stock. Top right: **Railroad Earth**, tour poster, 18" x 24" four color screen print on specialty French Paper stock. Bottom left: **Jeff Tweedy**, The Orange Peel, four color screen print on specialty French Paper stock. Bottom right: **Jeff Tweedy**, Egyptian Room, three color screen print.

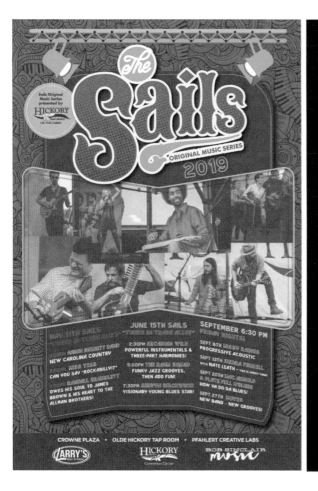

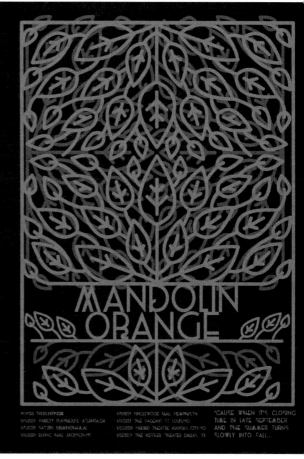

The Sails Music Series, Downtown Hickory, 11" x 17" digital on poster stock.
Mandolin Orange, tour poster, 18" x 24" two color screen print.

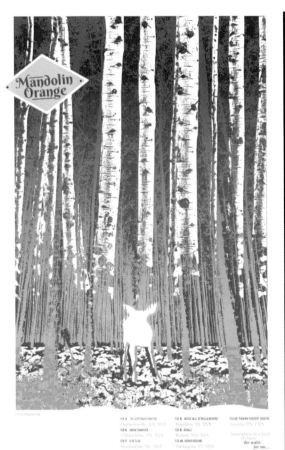

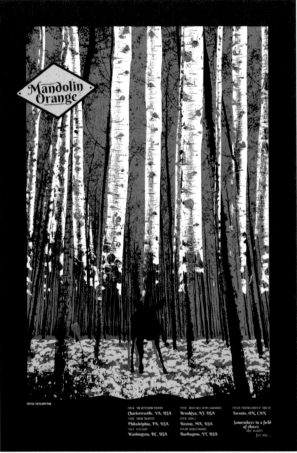

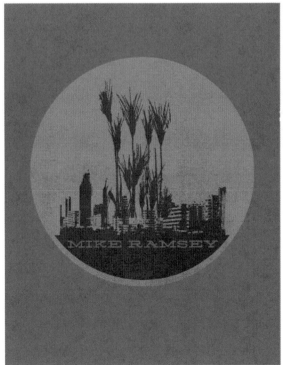

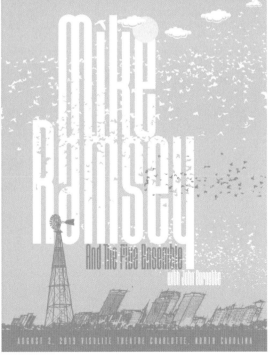

Top left and right: **Mandolin Orange**, tour poster, 18" x 24" four color screen print on white and black stock.
Bottom left: **Mike Ramsey**, promo poster, 11" x 17" digital on poster stock. Bottom right: **Mike Ramsey**, promo poster, 18" x 24"
screen print on poster stock.

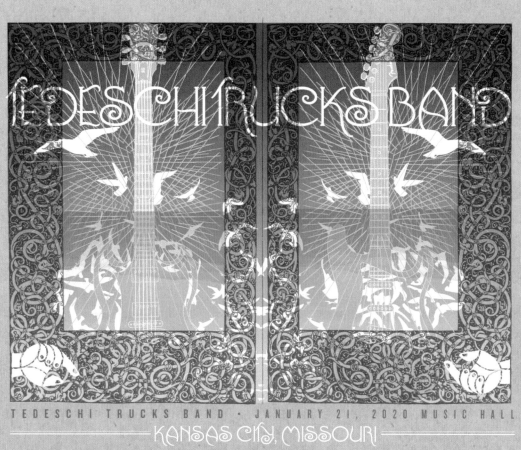

Tedeschi Trucks Band, Kansas City Music Hall, 24" x 18" four color screen print on specialty French Paper stock.

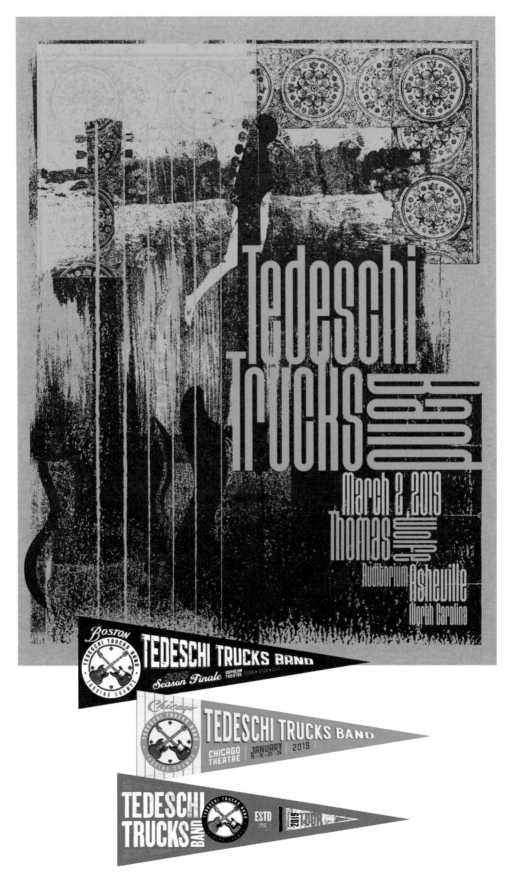

Tedeschi Trucks Band, Thomas Wolfe Auditorium, 18 x 24, two color screen print on specialty French Paper stock. **Tedeschi Trucks Band**, screen printed felt pennants.

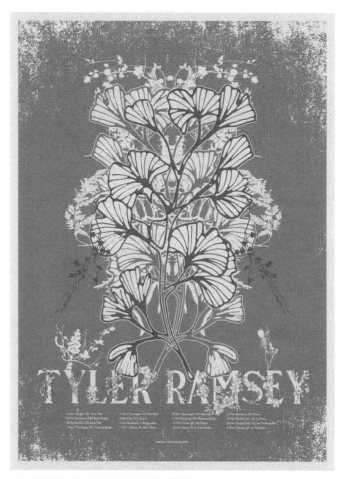

Tyler Ramsey, tour poster, three color screen print on specialty French paper stock.

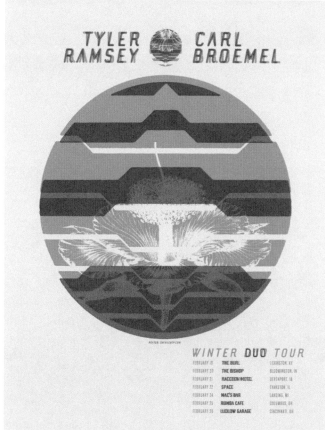

Tyler Ramsey & Carl Broemel, tour poster, two color screen print on specialty French paper stock.

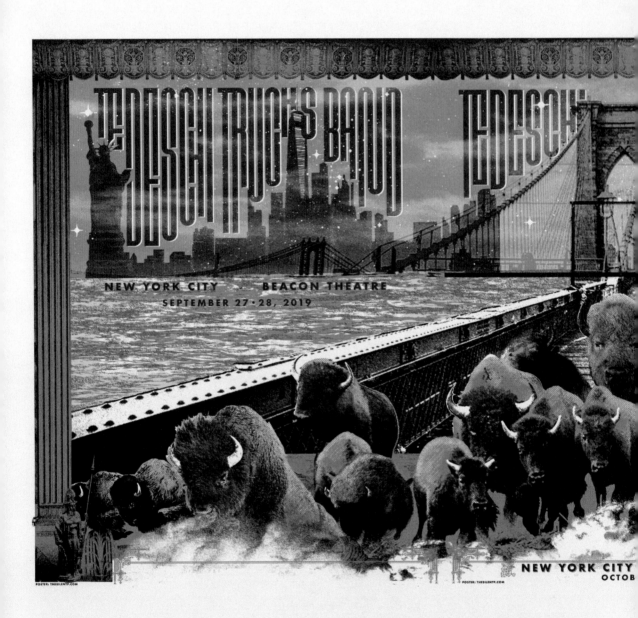

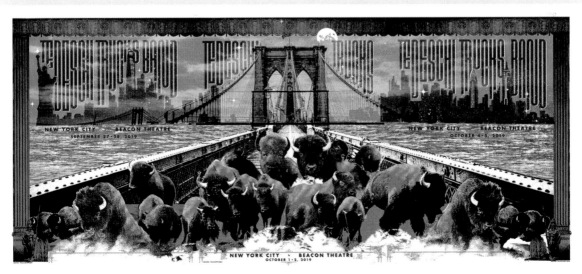

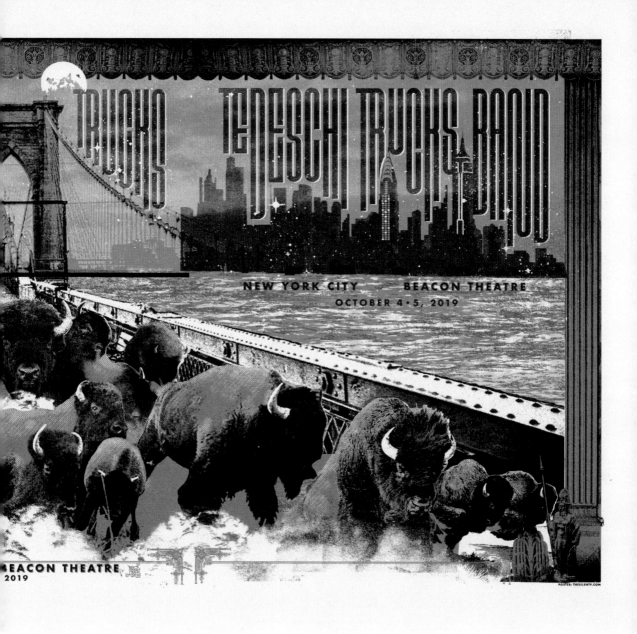

Tedeschi Trucks Band, Beacon Theatre, each poster 18" x 24" five color screen print with gold metallic, semi-opaque white and glow-in-the-dark inks.

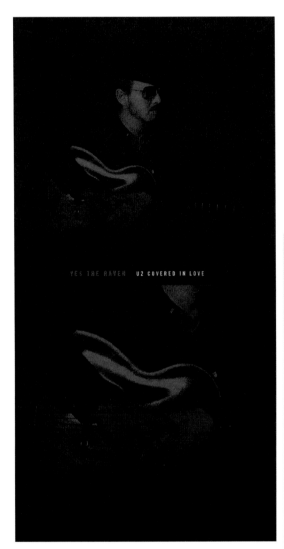

Yes The Raven, album release poster, 11" x 17" digital on poster stock.
Wilco, Advent calendar three color print on cardboard.

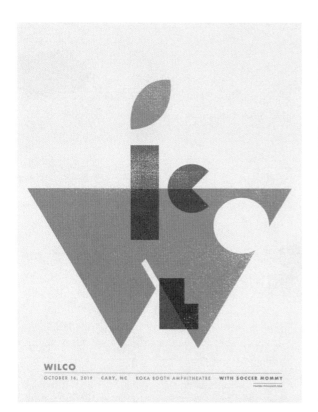

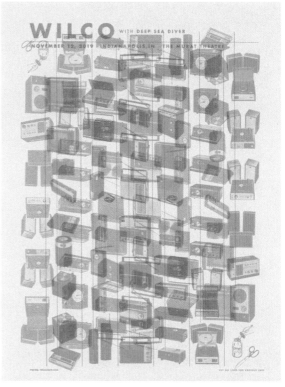

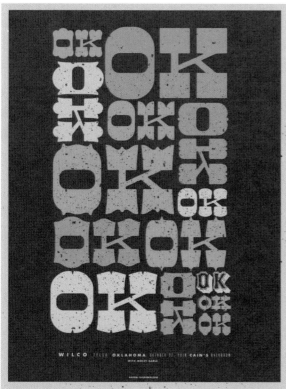

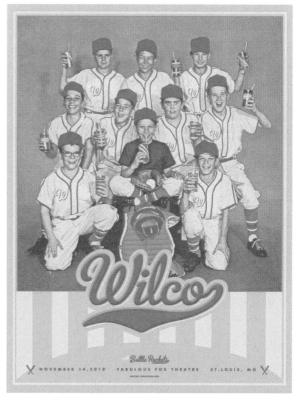

Top left: **Wilco**, Koka Booth Amphitheatre, three color screen print on specialty French Paper stock. Top right: **Wilco**, The Murat Theatre, two color screen print on specialty French Paper stock. Bottom left: **Wilco**, Cain's Ballroom, three color screen print on specialty French Paper stock. Bottom right: Bottom right: **Wilco**, Fabulous Fox Theatre, four color screen print on specialty French Paper stock.

2020

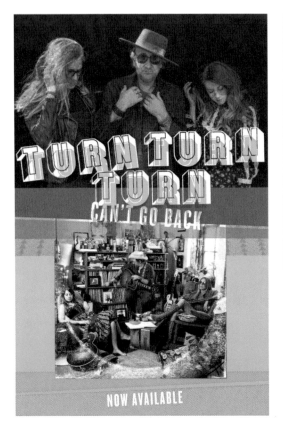

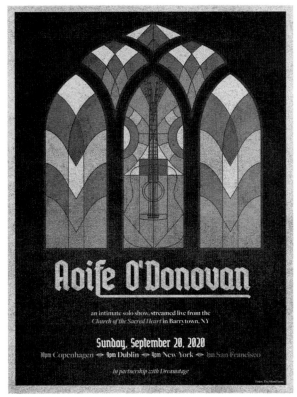

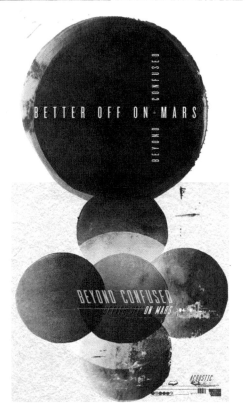

Top row: **Turn Turn Turn**, album release poster, 11" x 17" digital on poster stock. Bottom left: **Aoife O'Donovan**, Church of the Sacred Heart, 18" x 24" digital print on poster stock. Bottom right: **Beyond Confused**, album release poster, 11" x 17" digital on poster stock.

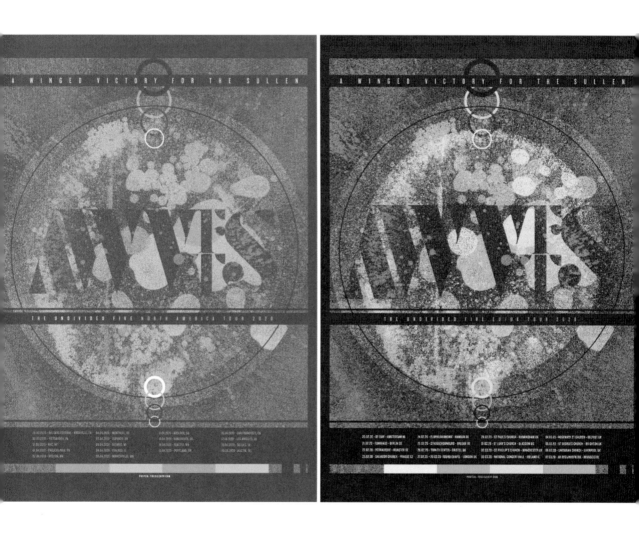

A Winged Victory, NA tour poster, four color screen print.(The Covid pandemic halted print production just as this was getting fun.)
A Winged Victory, EU tour poster, four color screen print on black stock.

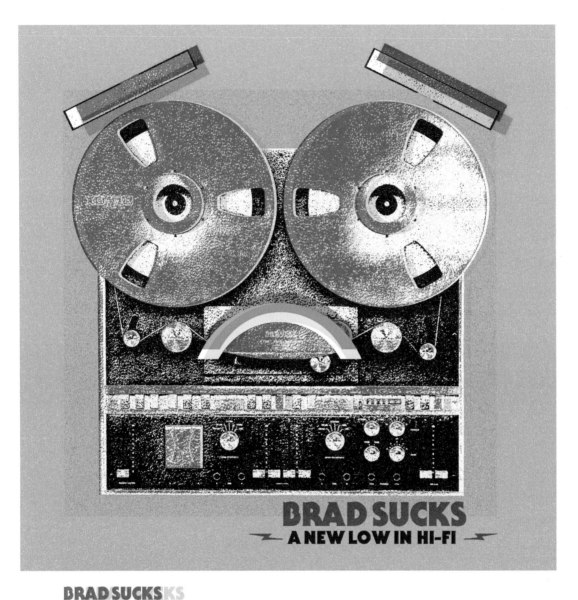

Brad Sucks, album release poster, digital on poster stock.

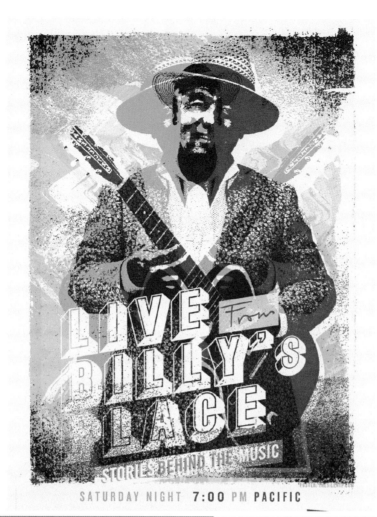

Live at Billy's Place,
Live streaming concert
poster, web only.
(Poster won a Summit
Silver Award).

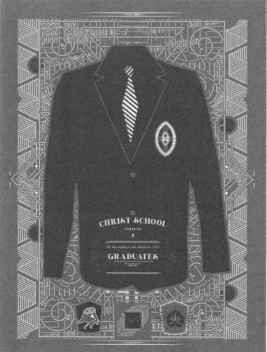

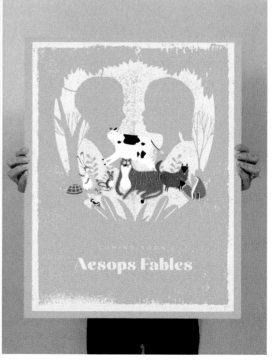

Christ School Graduates, Online graduation commemorative poster, 18" x 24" screen printed with gold metallic and green flocking material (velvet-like feeL). **Children's Theatre of Charlotte,** Aesop Fables digital on poster stock.

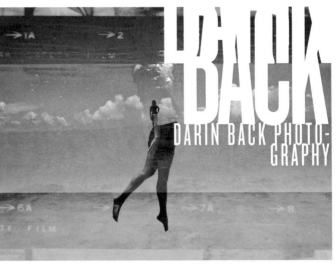
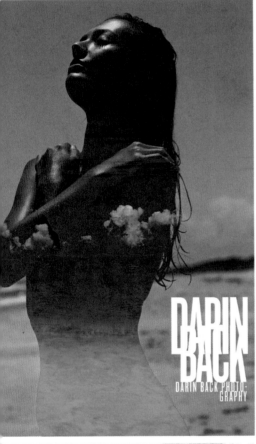
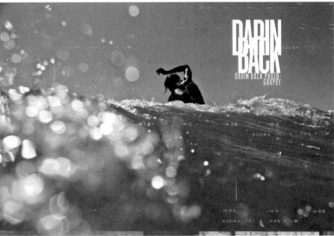

Darin Back Photography, promo poster, 12" x 18" digital on poster stock.

Dream Sitch (Floating Action & Michael Nau), album release poster, 11"x 17" digital.

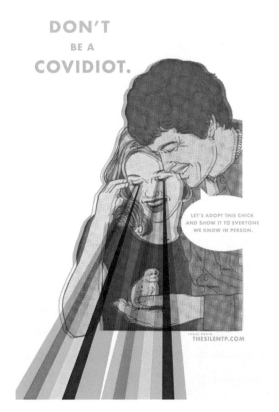

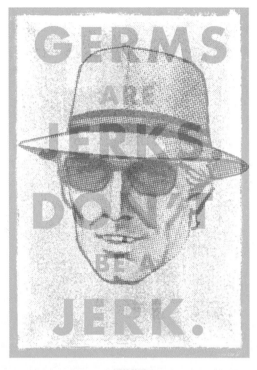

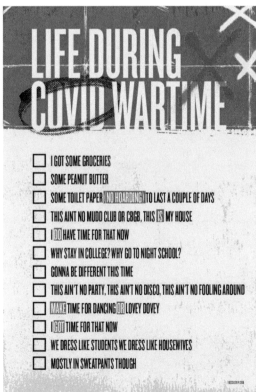

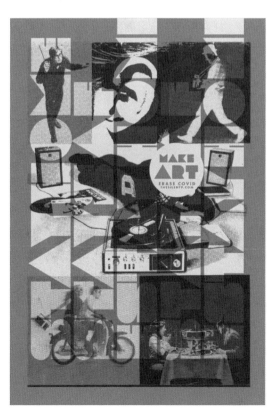

Top left: **Don't Be a Covidiot**, Erase Covid poster campaign, 12" x 18" digital on poster stock. Top right: **Germs Are Jerks**, Erase Covid poster campaign, 12" x 18" digital on poster stock. Bottom left: **Life During Covid Wartime**, Erase Covid poster campaign, 12" x 18" digital on poster stock. Bottom right: **Make Art**, Erase Covid poster campaign, 12" x 18" digital on poster stock.

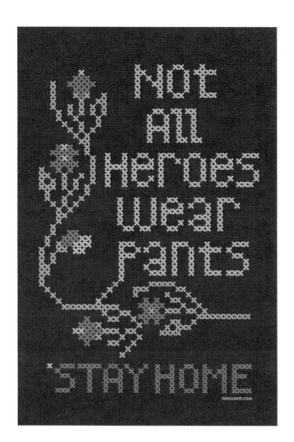

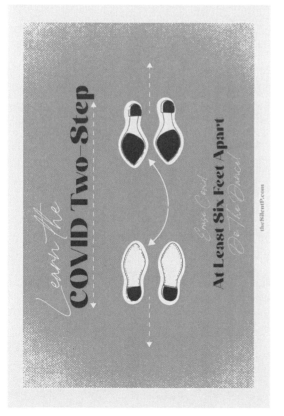

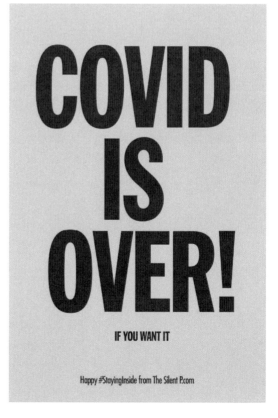

Top left: **Not All Heroes Wear Pants**, Erase Covid poster campaign, 12" x 18" digital on poster stock. Top right: **Stay Home**, Erase Covid poster campaign, 12" x 18" digital on poster stock. Bottom left: **Covid Two-Step**, Erase Covid poster campaign, 12" x 18" digital on poster stock. Bottom right: **Covid Is Over!**, Erase Covid poster campaign, 12" x 18" digital on poster stock.

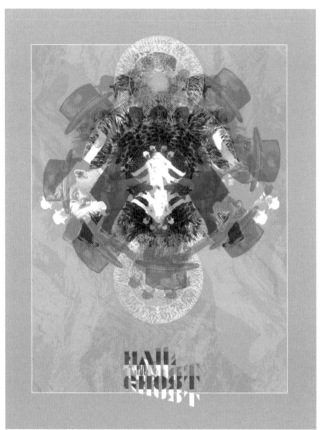

Hail The Ghost, promo poster, 18" x 24" digital on poster stock.
Pearl Jam 'Just Breathe', art print, 18" x 24" four color screen print on specialty French Paper stock (variant version).

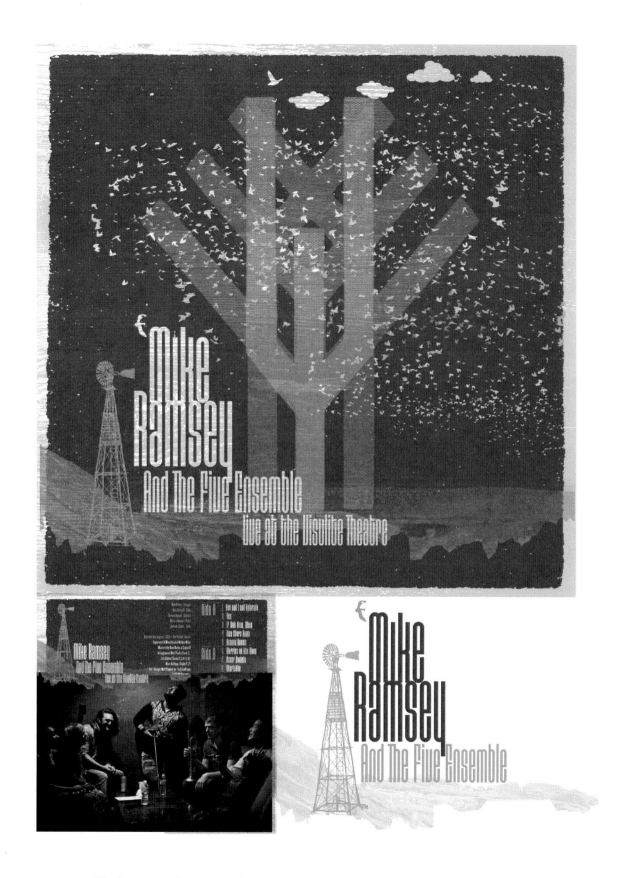

Mike Ramsey And The Five Ensemble, Album release poster, 11" x 17" digital on poster stock.

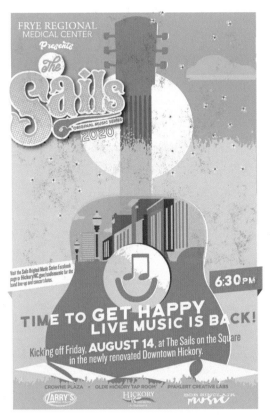

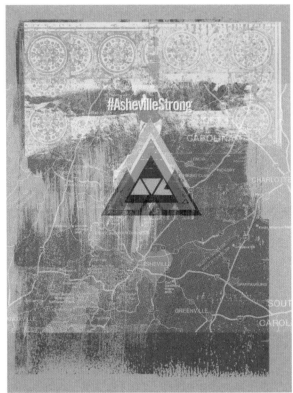

Top left, **The Sails Music Series**, Downtown Hickory, 11" x 17" digital on poster stock. Top right, **Asheville Strong**, promo poster, 12" x 18" digital on poster stock. Bottom left, 'hope', 11" x 17", **Vino THIRST**, ad campaign poster, 18" x 24" digital on poster stock.

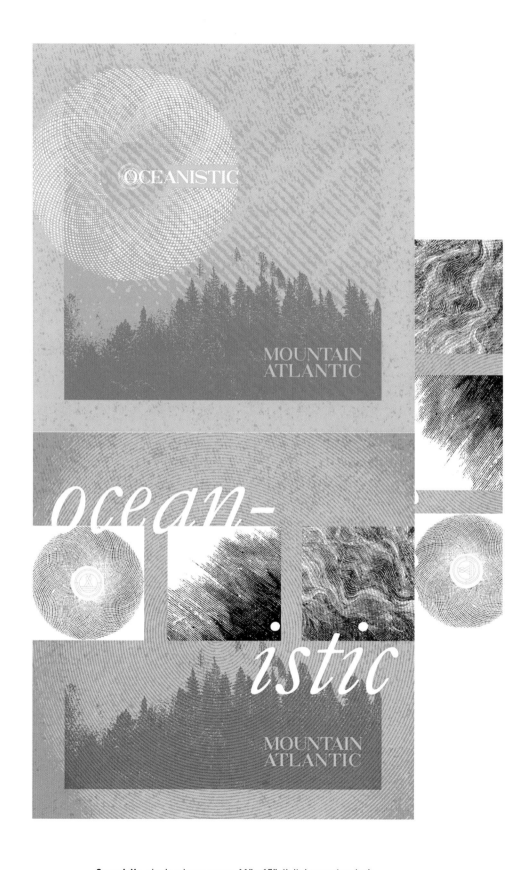

Oceanistic, single release promo, 11" x 17" digital on poster stock.

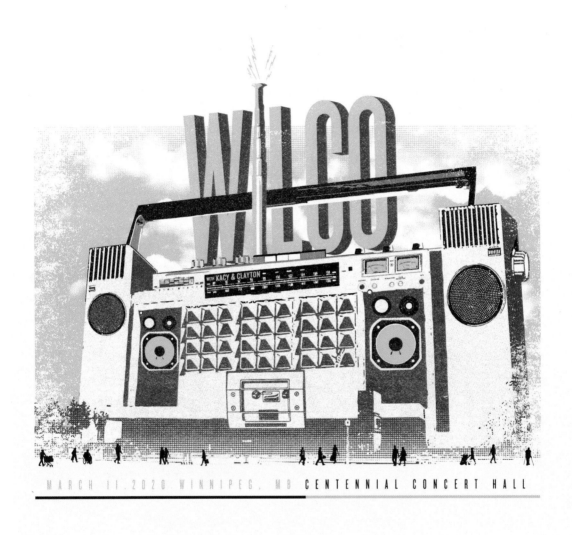

Wilco, Centennial Hall, 24" x 18" three color screen print on cream stock.

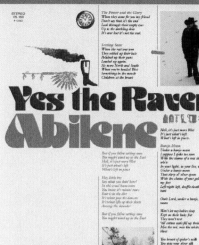

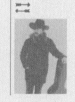

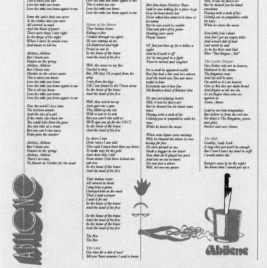

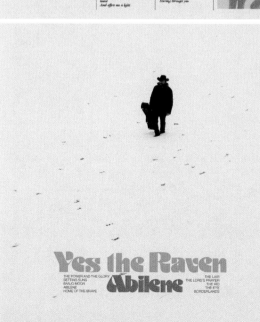

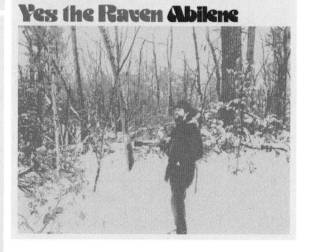

Yes The Raven, album release lyric sheets 12" x 12" digital on poster stock and 11"x17" promo poster.

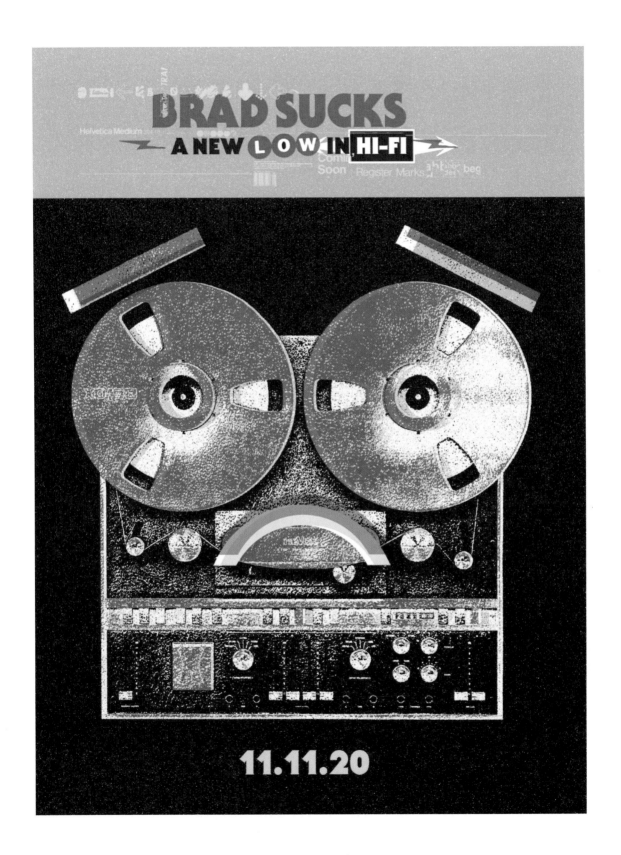

Brad Sucks, album release poster, 11" x 17" digital on poster stock.

Thank You

'Thank You' doesn't really cover it for my mom and dad. Gratitude in the fullest sense gets close. In my younger years, I took for granted that my parents, Tom and Sandy Pfahlert, were always encouraging both me and my brother's creativity, their always being a loving and supportive team for my career in the challenging professional arts & design world was huge. I got to learn the trade under my Pop's tutelage, an amazing gift that I truly treasure. The fact that years later I would get a chance to have my dad actually work along with me in my small business was immeasurable. I love you guys now and forever.

Thanks to my wife, Nana, who endured many late night deadlines and venting sessions with patience and understanding, doing her best to empathize with what a "big deal" it was that a client didn't agree with my typeface choice, or a request to "make the logo bigger". Thank you to my big brother Mark for always being encouraging as well as being my creative brother in arms. Thanks to my uncle Joseph Kosuth, whose groundbreaking path in the conceptual art world has always been inspiring. Michael Sheets was my high school art teacher, and the perfect example how a good teacher can make a HUGE difference in the life path of a student, maybe without realizing it, so thank you Michael! Thanks to Clay Hayes who for years ran the (in)famous site Gigposters.com, an entertaining source of endless information and classic discussion threads - man, I miss that place. Thanks also to the team at Wilco (Crystal, Brandy, Andy and Ben), who gave me my first shot at an official gig poster, simply because I asked. And thanks to ALL the bands and managers who reached out over the years because they saw something they liked, I'm eternally thankful. Thank you to all the amazing photographers who allowed their beautiful images to be a special part of this book. Big thanks to all the printers who printed my work, your willingness to experiment and be a partner in the print process has always meant a lot. Big thank you to both Jeff Tweedy and David Carson for writing the introduction and foreword for my poster book - typing this sentence is a bit surreal.

Lastly, to all the poster fans - YOU make this happen. So, many, *many* thanks for that. It's nice to know a lot of these are framed and hanging in people's homes all over the world...from here in the U.S.A. to Ireland, Italy, Australia and Japan - it is just amazing to me, and always will be.

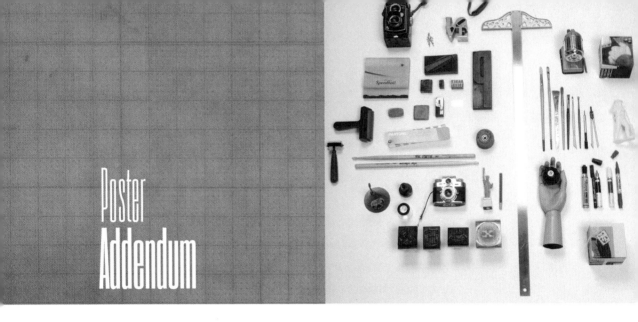

Poster
Addendum

The following pages reflect the poster work that
thankfully came back when musicians could once
again go back on tour.

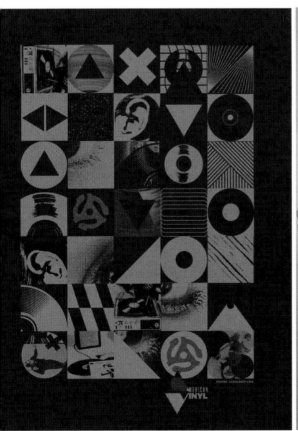

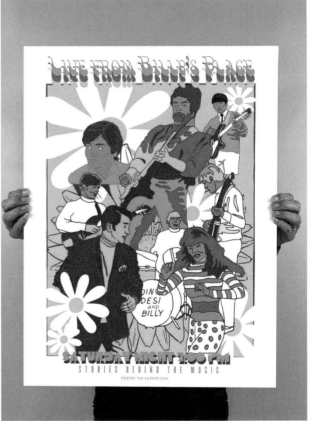

American Vinyl, 18" x 24" screen printed with gold metallic on black.
Live From Billy's Place, 18" x 24" digital color on poster stock.

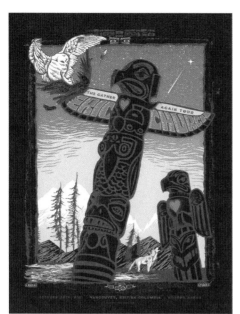
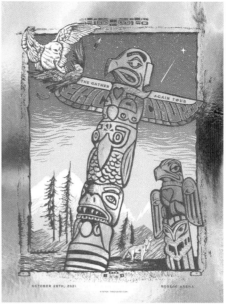
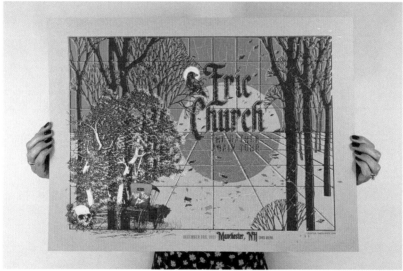
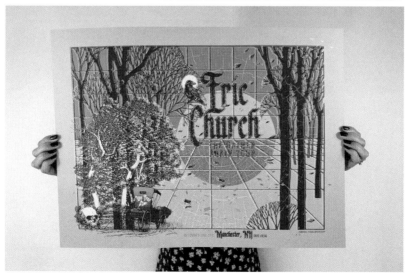

Eric Church, The Gather Again Tour, both 18" x 24". Foil stock variant for Vancouver.

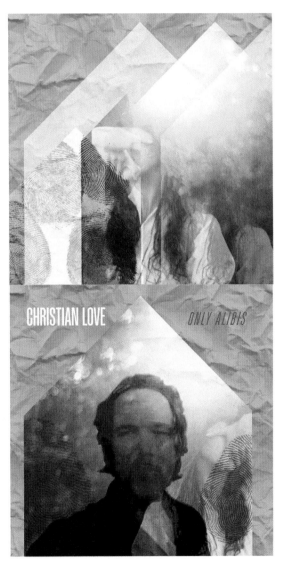

Christian Love, 11" x 17" Album release poster.

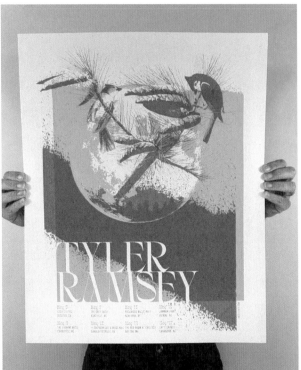

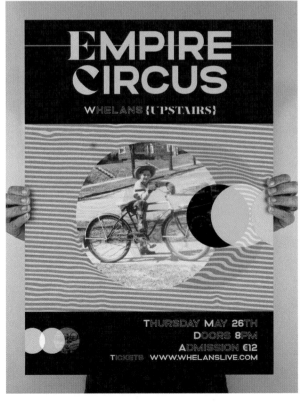

Tyler Ramsey, 18" x 24" two color screen print on French Paper.
Empire Circus, 18" x 24" digital color on poster stock.

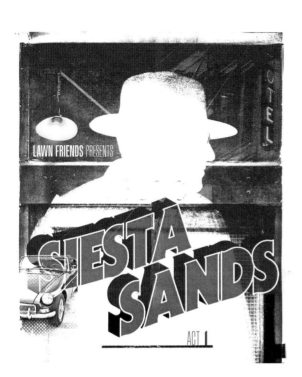
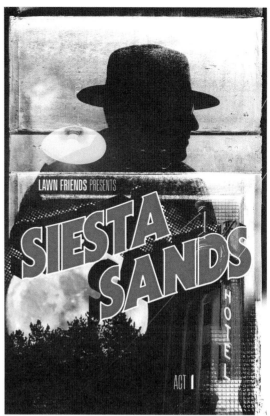
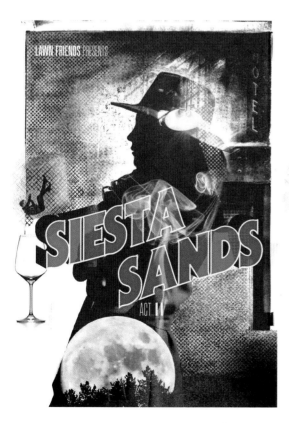
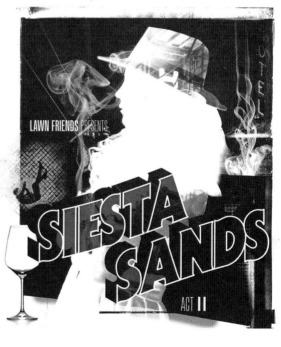

Lawn Friends, 11" x 17" Album release posters.

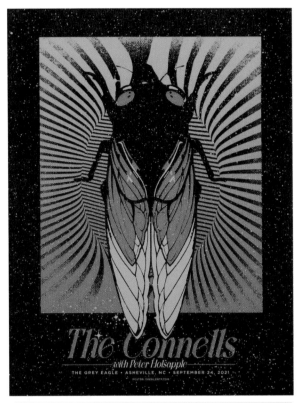

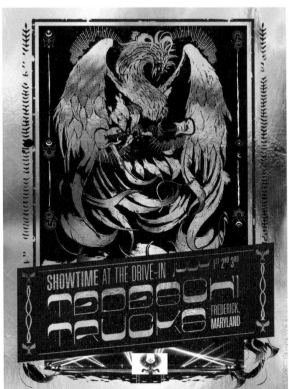

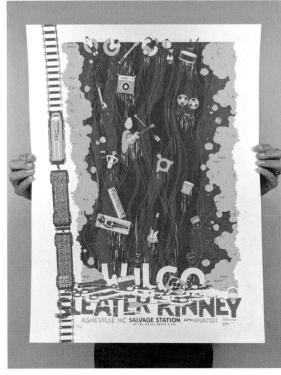

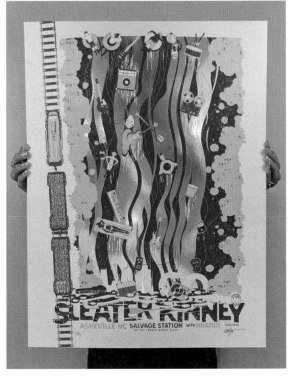

The Connells, 18" x 24" two color screen print on black.
Tedeschi Trucks Band, 18" x 24" one color screen print on foil stock
Wilco and Sleater Kinney, 18" x 24" five color screen print on white stock and foil variant.

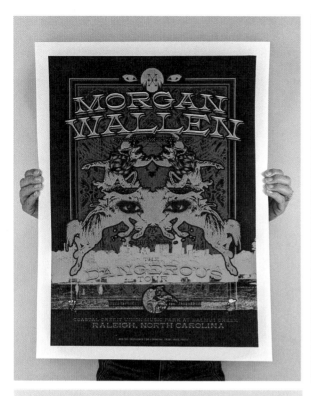

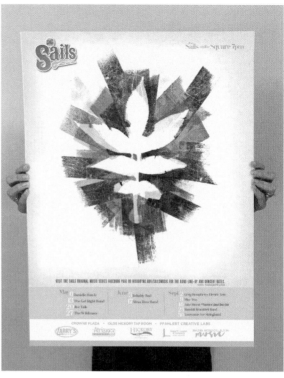

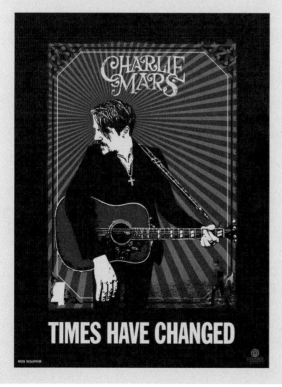

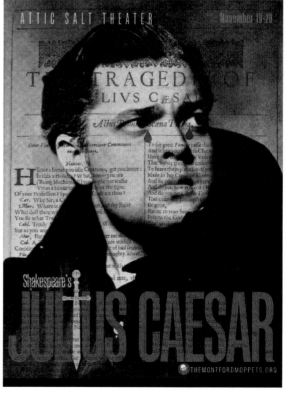

Morgan Wallen, 18" x 24" three color screen print on black.
Sails Concert Series, 18" x 24" digital color print on poster stock.
Charlie Mars, 18" x 24" two color screen print on cream stock.
Julius Caesar for The Moppets, 18" x 24" digital color on poster stock.

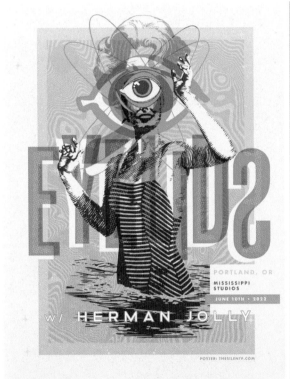

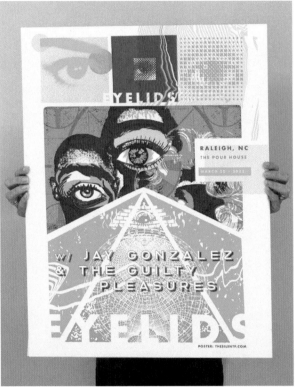

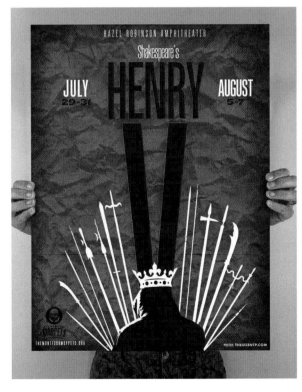

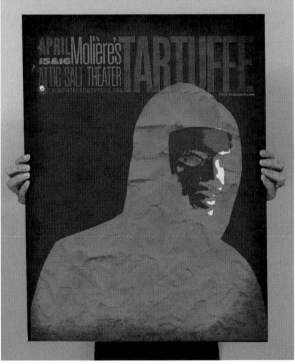

Eyelids, 18" x 24" three color screen print on black.
Eyelids, 18" x 24" digital color print on poster stock.
Henry V for The Moppets, 18" x 24" digital color on poster stock.
Tartuffe for The Moppets, 18" x 24" digital color on poster stock.

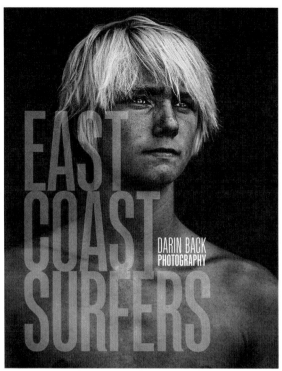

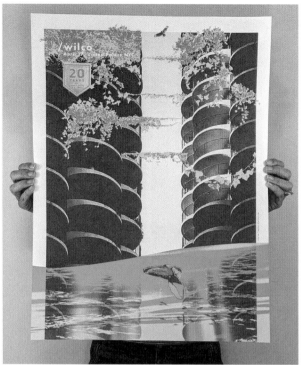

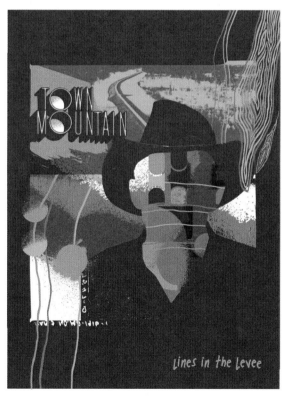

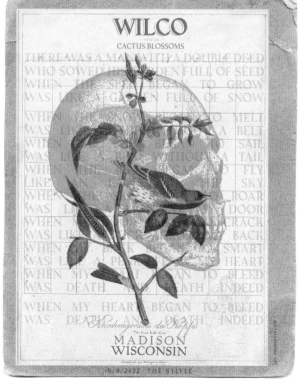

Darin Back, 36" x 48" digital color on foam core.
Wilco, 18" x 24" six color on French Paper stock.
Town Mountain, 18" x 24" four color screen print.
Wilco, 18" x 24" four color process with one spot color.